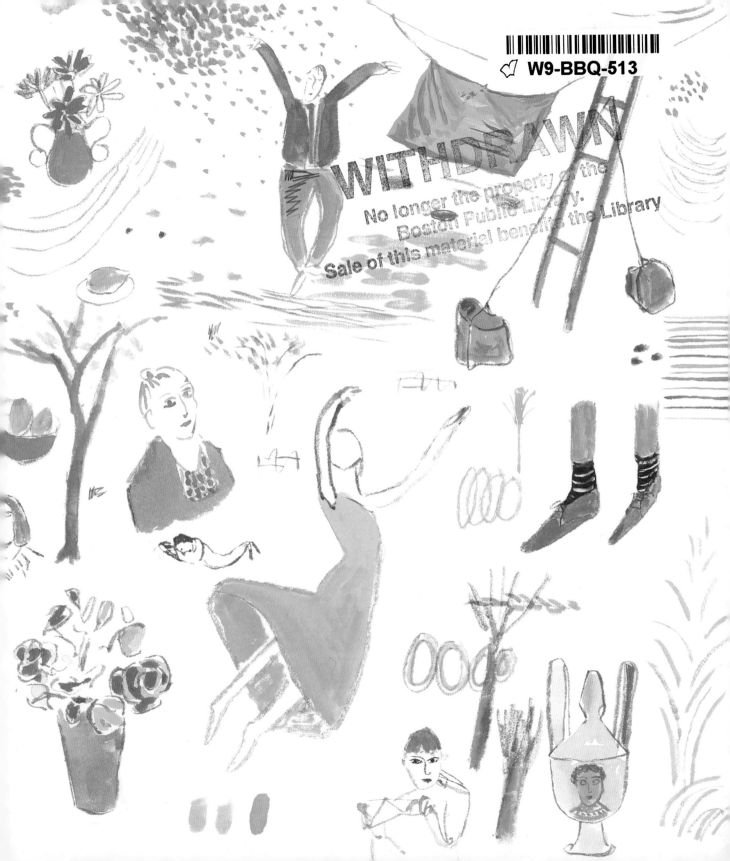

W9-BBQ-513

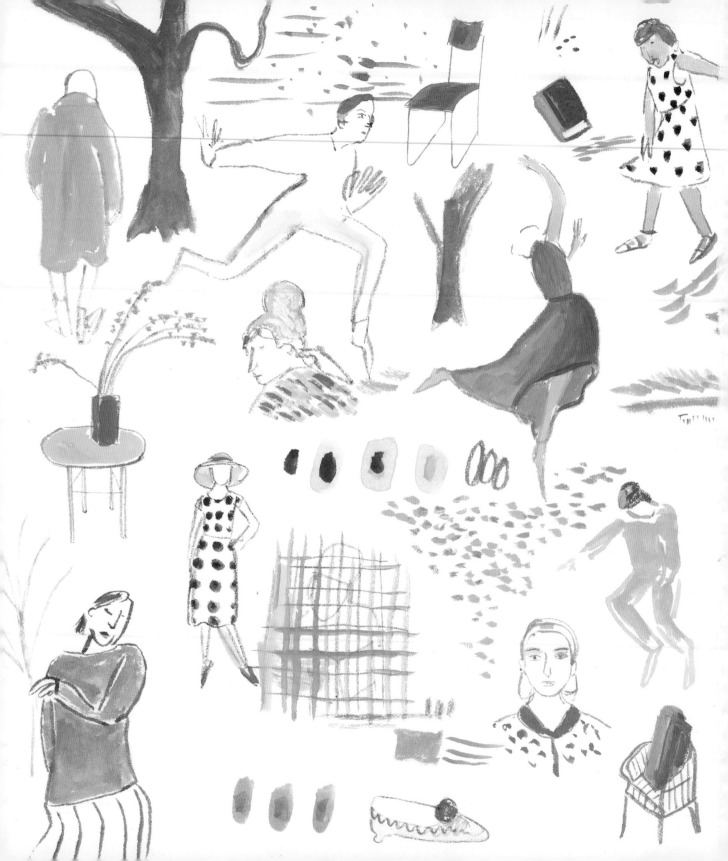

My Favorite Things

My Favorite Things

Maira Kalman

HARPER
DESIGN

An Imprint of HarperCollins Publishers

FOR

Lulu Bodoni Kalman and Alexander Tibor Kalman,

who illuminate my path at every turn

and know how to laugh.

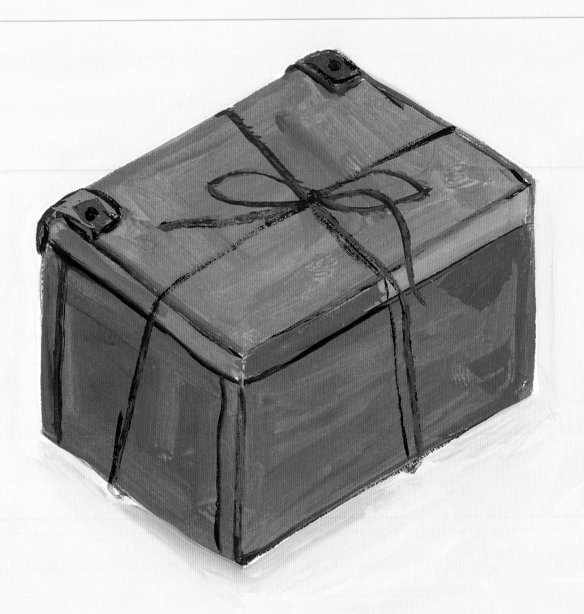

CONTENTS

Introduction

The Phone Rings.

In 2011 I was invited by the Cooper-Hewitt, National Design Museum in New York City to curate an exhibit based on their collection.

Like a shopper in some great, mad department store that housed many centuries' worth of objects, I browsed and inspected their archives for a year or so.

The pieces that I chose were BASED on
ONE thing ONLY — a gasp of DELIGHT.

Isn't that the ONLY WAy to CuRaTE A LiFE?
To live among Things that make you GASP with DeLight?

BUT FIRST, a LiTTLe bit of BACKGROUND on the
PERSON doing the CHOOSING.

PART I
THERE WAS A SIMPLE AND GRAND LIFE

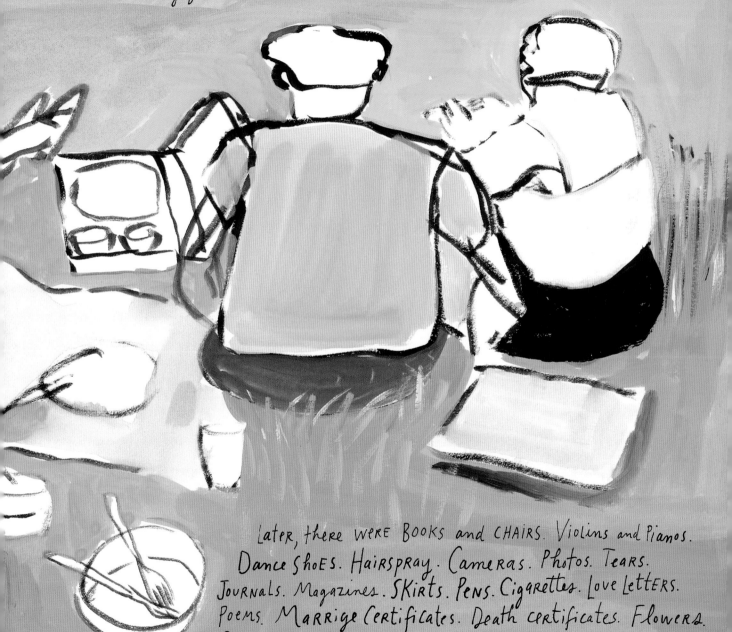

Picnics. Sandwiches with hard-boiled Eggs and CUCUMBERS. Lemon ICES. Flip-Flops. SHEETS and PilLOWCASES drying on the clothesline. BLindingly WHITE. Starched and Ironed.

Later, there WERE BOOKS and CHAIRS. Violins and Pianos. Dance ShoES. HAIRSPRAY. Cameras. Photos. Tears. Journals. Magazines. SKirts. Pens. Cigarettes. Love LettERS. Poems. MARRIgE Certificates. Death certificates. FloweRs. Paint Rags. Moss and Fezzes. Useless and precious objects. Taking up Space. Taking up TIME.

There are MEMORIES.

VAGUE and FLEETING. OR SHARP and SEARING.

MOODS leaving a SENSE of URGENCY. OR disquiet.
OR a SENSE OF Well-Being and BeLonging.

And ALways, oBjects inhabit the memories.

> I am sitting on the COOL FLOOR
> NEXT To a BED, READING a BooK.

> The Window is open and the curtain
> Billows in the Breeze. My parents
> have Left me alone in the RooM.

I AM Not even SURE thERe was Really
a RooM LiKe that.

There aRe some RooMs, ReaL oR imagined,
some moments, some aspects of light
that haunt you.

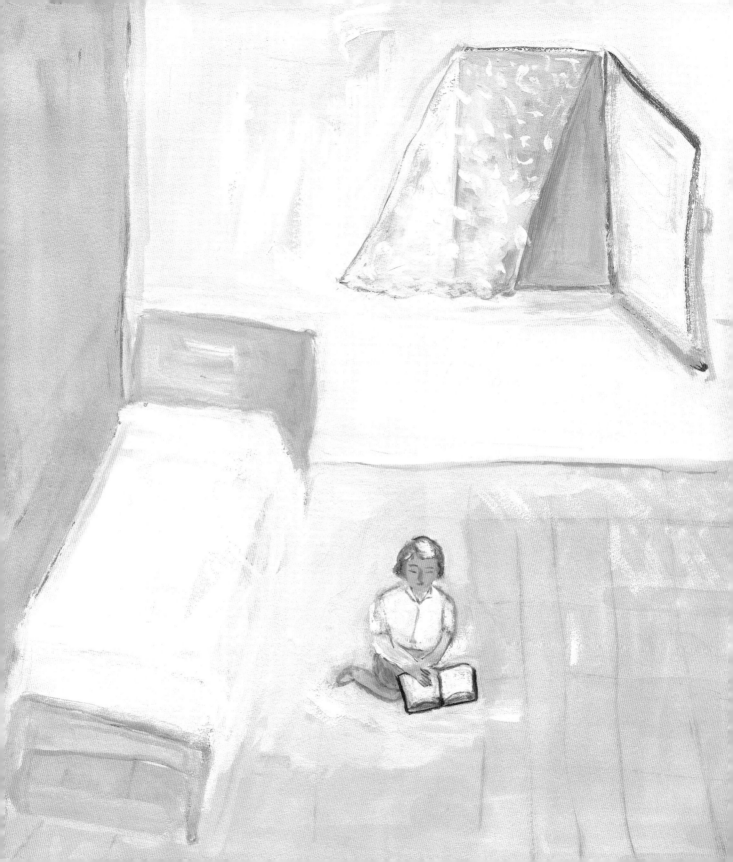

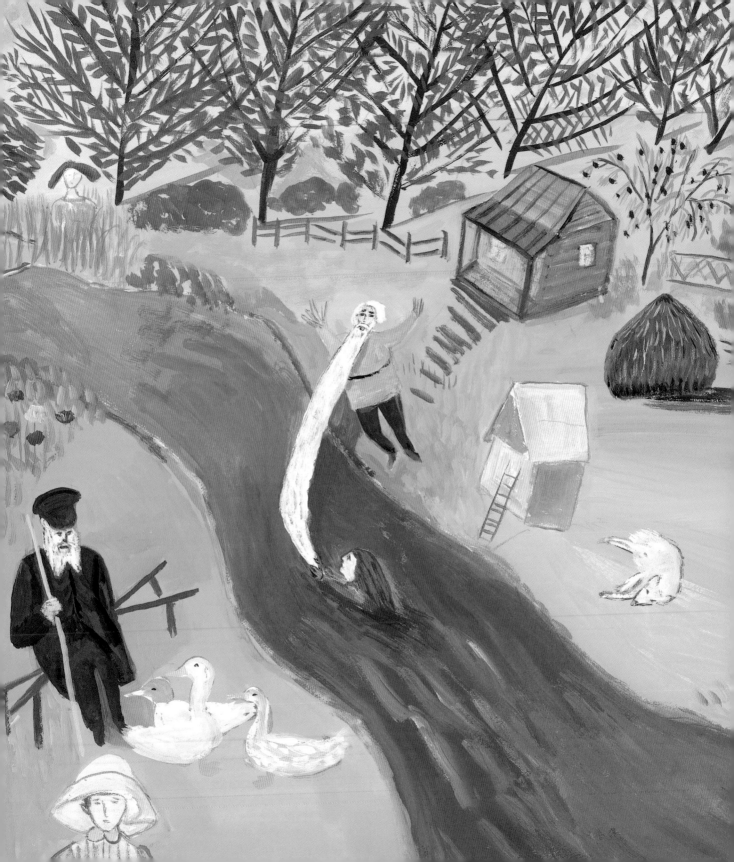

My Family came from a village in Belarus, a collection of SHACKS on the RIVER SLUCH.

One day my mother fell into the RIVER and almost drowned. Her grandfather pulled her out with HIS BEARd. From then on she was afraid of the water.
Her Sister was a fearless swimmer.
She was fearless in general.

The children would RUN WILD NEAR forests of Wild BLUEberries.

My grandfather played the trumpet in the aRMy.

Somewhere not too far away, the CZAR and CZARina with their beautiful children, all in white, were taking tea in their PALACE.

Soon that would end. As all things do.

THE GRAY SUIT

One day, my father was locked out of our
apartment in TEL AVIV. He tried to get in
by climbing down from a neighbor's terrace
on the THIRD floor to our terrace on the
second floor.
But he slipped and fell to the GROUND.
He FELL,
SLOWLY,
in his GRAY suit
and did NOT get HURT.

This was before I was born.
Before he took us to the United States.
Before we drank Coca-Cola or knew
what a television set was.

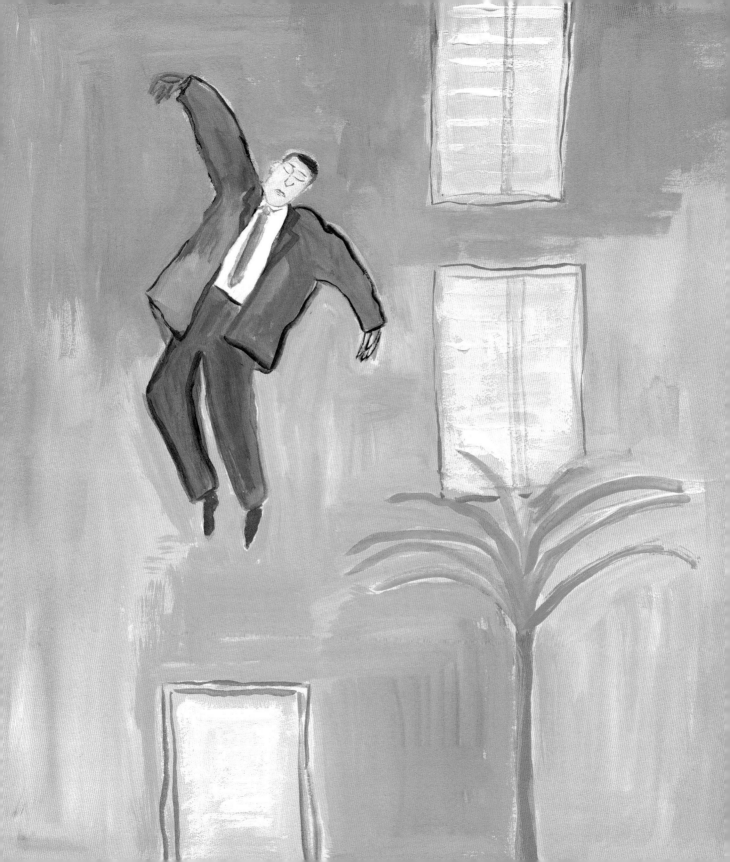

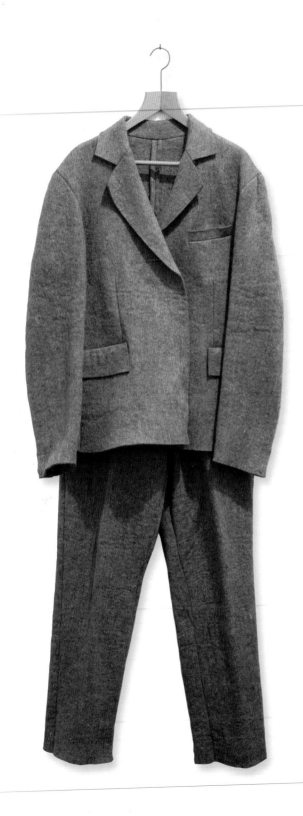

THE SAME YEAR
AS MY FATHER'S FALL,
Joseph Beuys Fell
From the Sky,
his airplane shot
down during
World War II.
Later he made
a gray Felt suit,
not at all Like
my father's.
BECAUSE hE WAS
an ARTIST
and My FatHeR
was DEFINITELY
Not AN ARTIST.

My FATHER WAS a DiAMOND DeALeR. A BON VIVANT.
HE WORE AFTERSHAVE and had a SUITCASE.
He TOOK US To NEW York City.

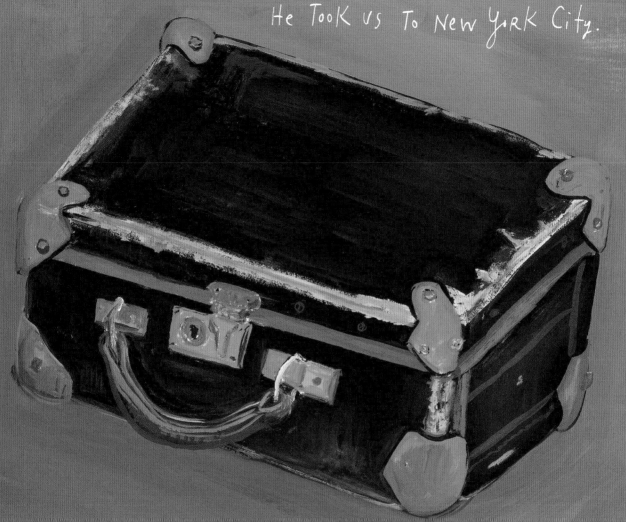

His SECRETARY WAS EsthER ARLiNSky.
She had a BLond BEEHive hairdo and
Called my father MR. B. He had a safe
in his office full of DiAMONDs that he let me count.

My mother missed her family but never complained.
She bore all sadness in silence making dinner in
our kitchen in the Bronx.

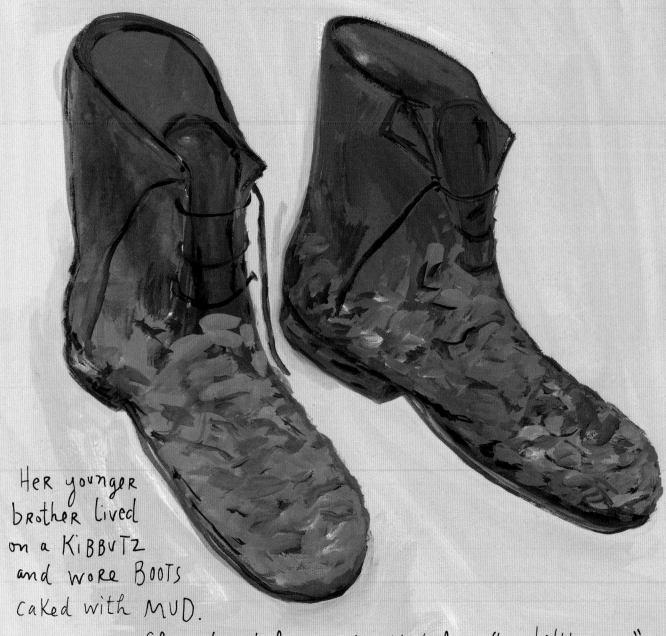

Her younger
brother lived
on a KIBBUTZ
and wore BOOTS
caked with MUD.

She adored him and called him "my little son."

She went to visit him and made him potato pancakes, grating the potatoes on this grater.

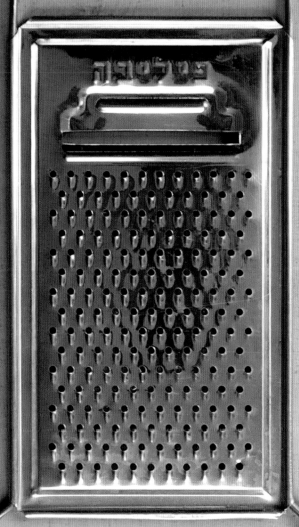

He brought her crates of fruit from the kibbutz.

They had sharp noses and sharp eyes and they sat and talked on the terrace for hours.

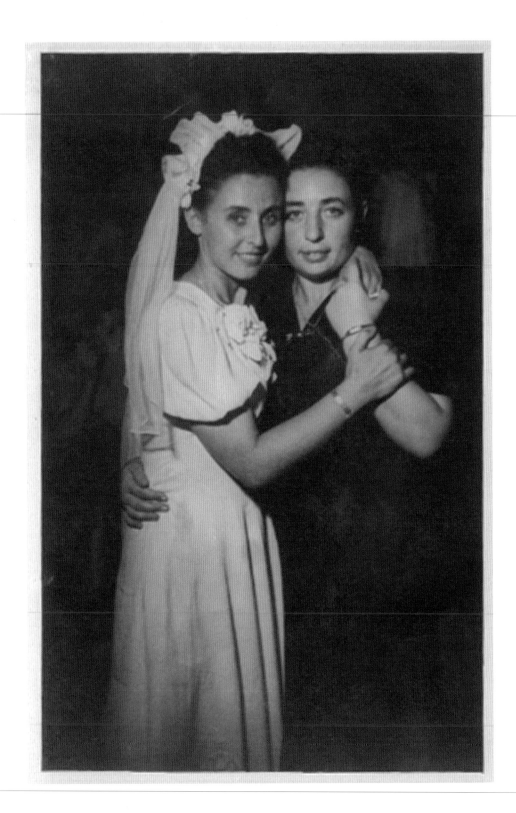

My mother was completely beautiful.
EVERYONE WAS in LOVE WITH HER.
IF TOLSTOY had bEEN ALIVE, HE WOULD HAVE loved hER MADLY.
So WOULD have GOGOL. KAFKA. NABOKOV.
Who ELSE?

BALZAC? OF COURSE. DOSTOEVSKY? WHY NOT?
OUR GENTLE NEIghBOR, the MAN with the
CROOKed THUMB? YES, he loved hER TOO.

BUT my FATHER WAS the LUCKY MAN.

ON the Wedding dAy, my mother and
hER Sister hugged each otHER with a
TRue and Simple LOVE.

My mother had misgivings.

She WAS frightened.

But she went through with the wedding.

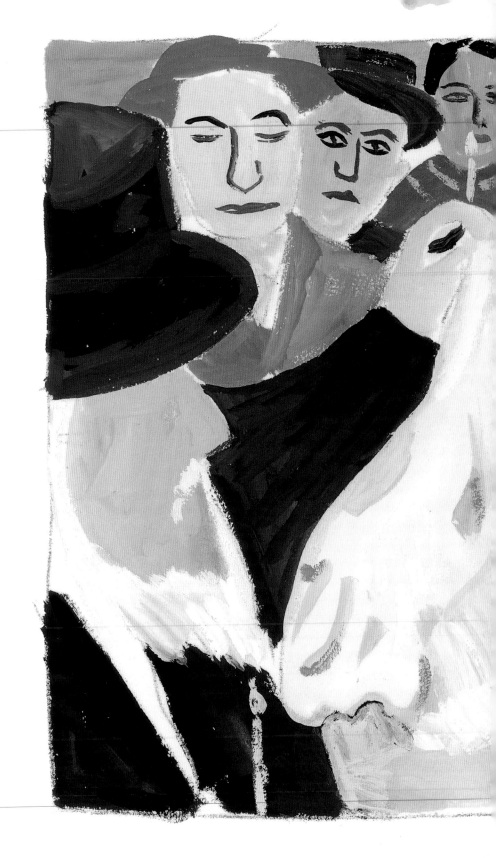

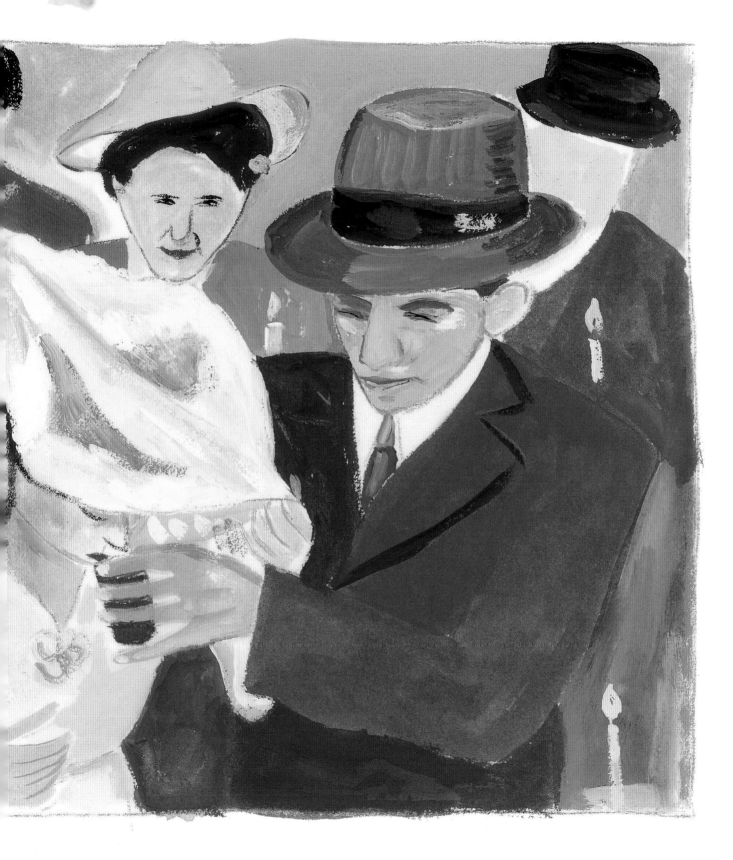

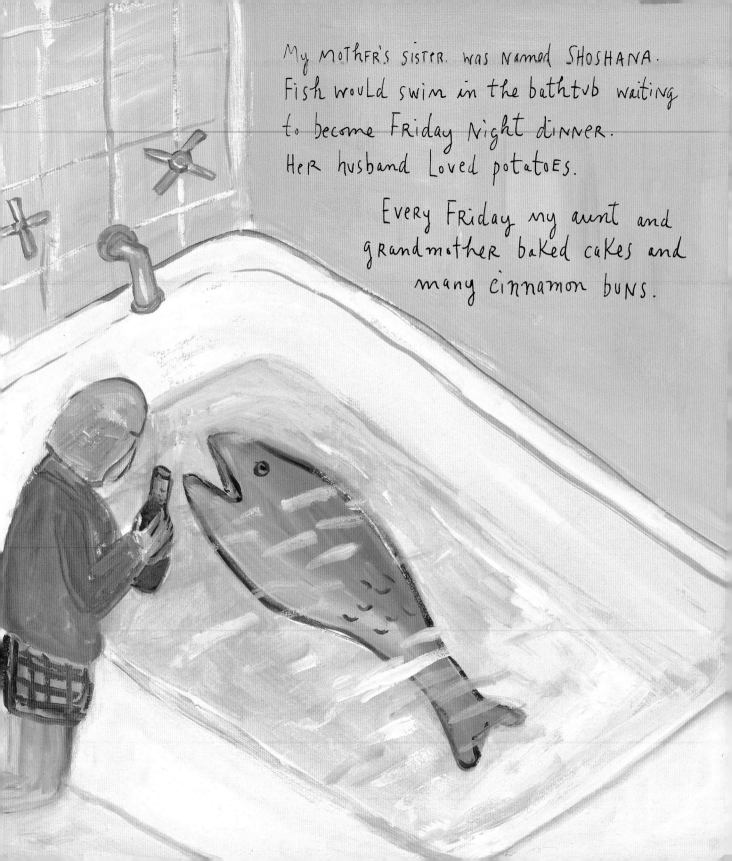

My MOTHER's SISTER was named SHOSHANA.
Fish would swim in the bathtub waiting
to become FRIDAY NIGHT dinner.
HER husband Loved potatoes.

Every FRIDAY my aunt and
grandmother baked cakes and
many cinnamon buns.

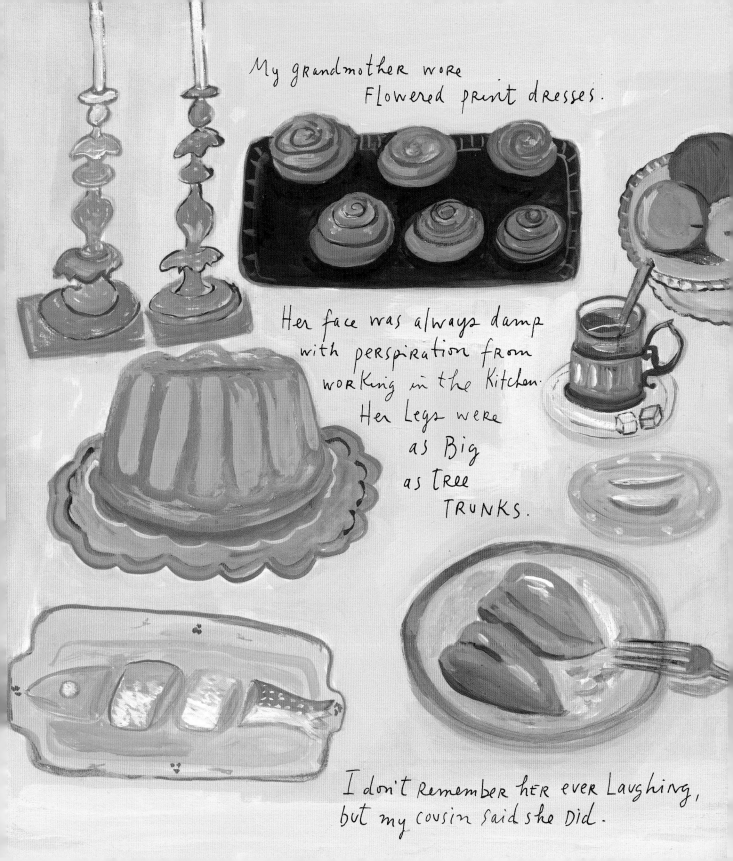

My grandmother wore
flowered print dresses.

Her face was always damp
with perspiration from
working in the Kitchen.
Her legs were
as Big
as tree
TRUNKS.

I don't remember her ever laughing,
but my cousin said she Did.

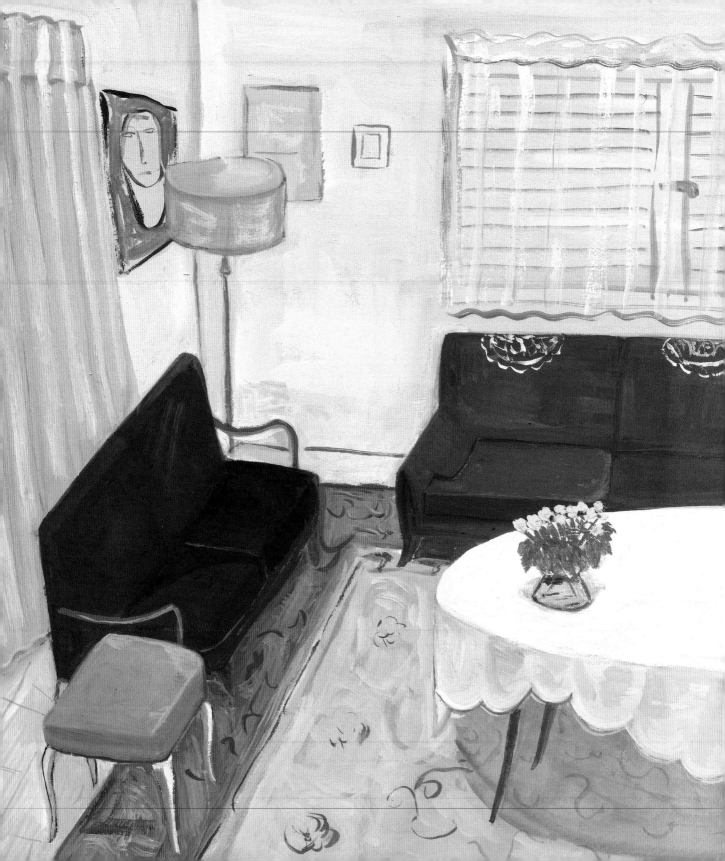

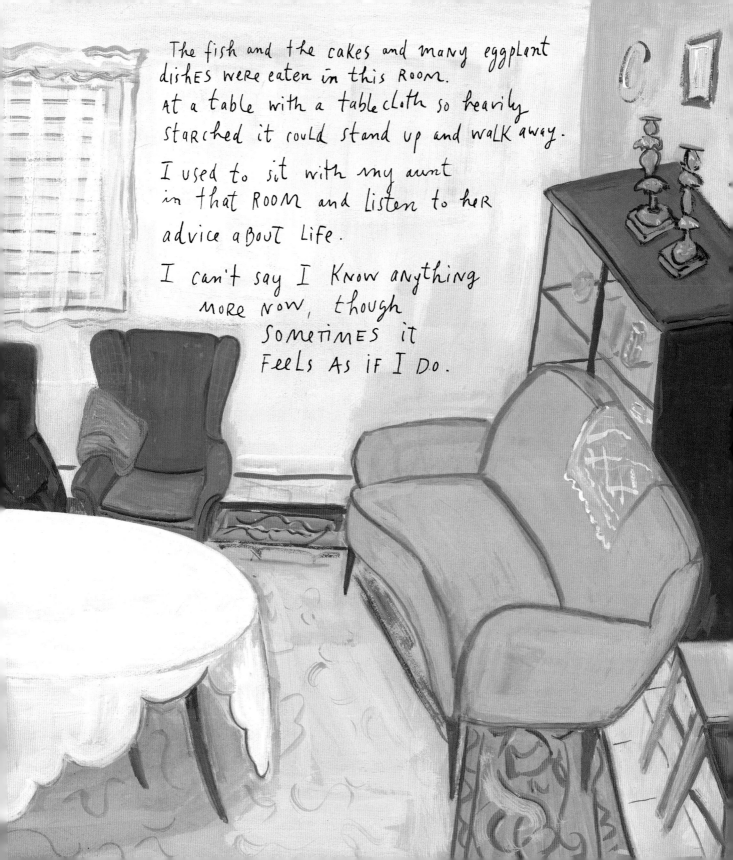

The fish and the cakes and many eggplant
dishes were eaten in this room.
At a table with a tablecloth so heavily
starched it could stand up and walk away.

I used to sit with my aunt
in that room and listen to her
advice about life.

I can't say I know anything
more now, though
sometimes it
feels as if I do.

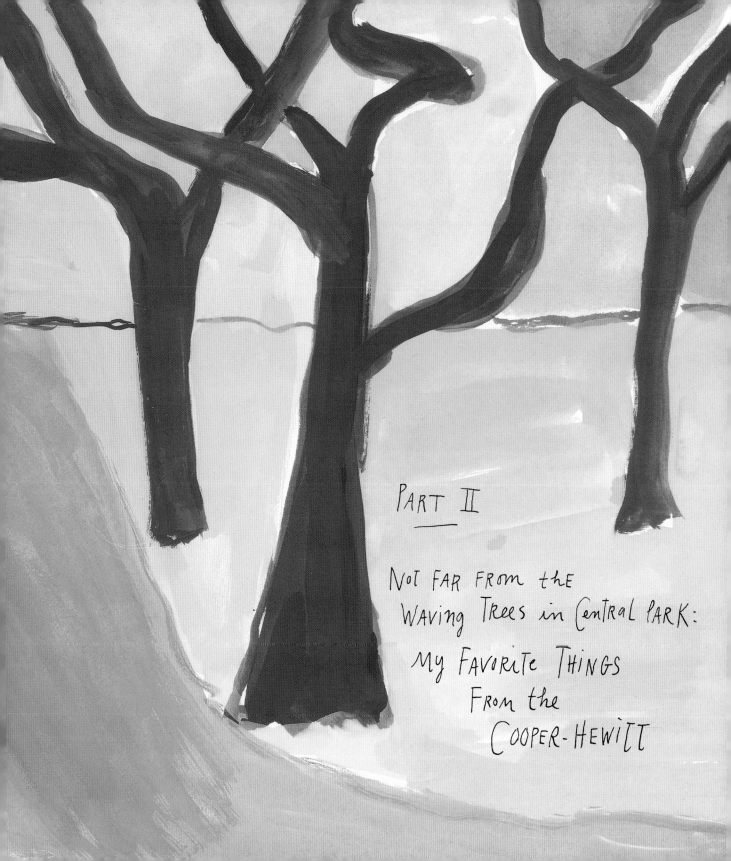

PART II

NOT FAR FROM the
WAVING TREES in CENTRAL PARK:

MY FAVORITE THINGS
FROM the
COOPER-HEWITT

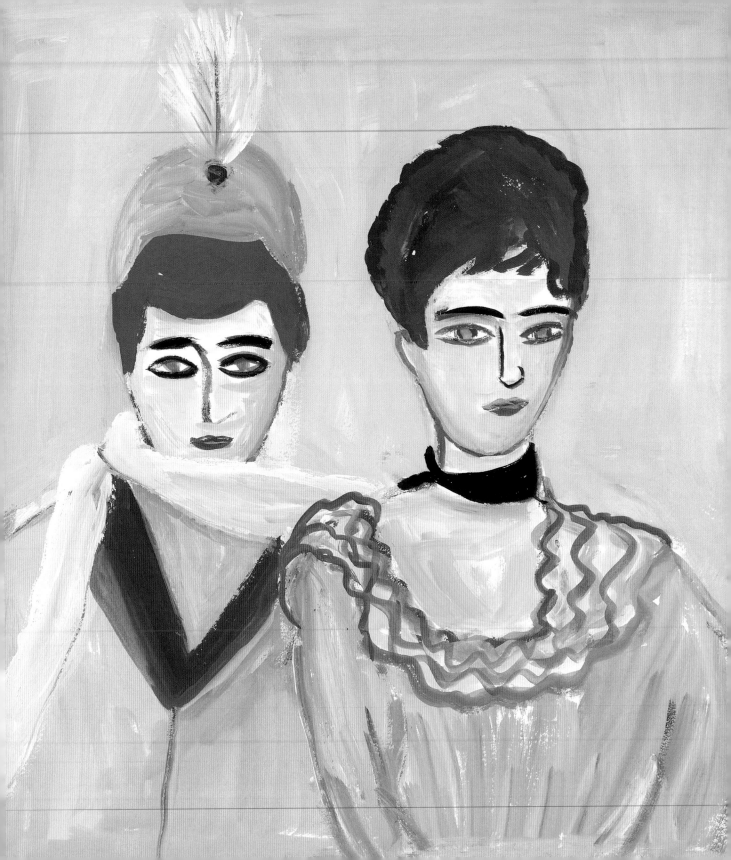

The Cooper-Hewitt, Smithsonian Design Museum, now Housed in the Carnegie Mansion on Ninety-First Street and Fifth Avenue, was founded by Nellie and Sally Hewitt. They were sisters. Vivacious and Eccentric. One Loved to DANCE. The other played the VIOLIN.

And they had some money to Buy things that they Loved. Inspired by visits to La Musée des Arts Décoratifs in Paris, they Began to collect Decorative Arts.

In the Nineteenth Century everyone was MAD for Collecting. Cabinets of Curiosities were All the Rage.

The Hewitt Collections became the basis of the museum as we Know it today. They are examples of beauty and utility that surround us from morning to Night. They speak of creativity, love of WORK, Curiosity, and enchantment.

The INSTALLATION I have assembled
is housed in what was once
the MUSIC Room in the CARNegie Mansion.

THERE aRe places to sit and things
to LooK at oR NoT LooK at.

There is a piaNo, and music will be
played in the Room.

And it has something
(oR everything) to do
with Life and Death.
And time. ALways time.

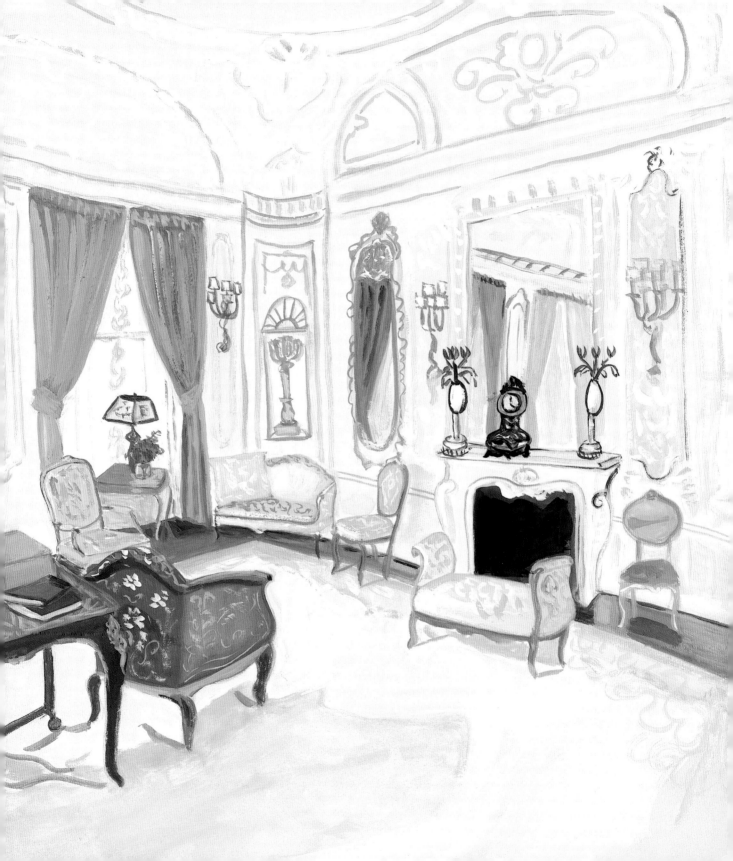

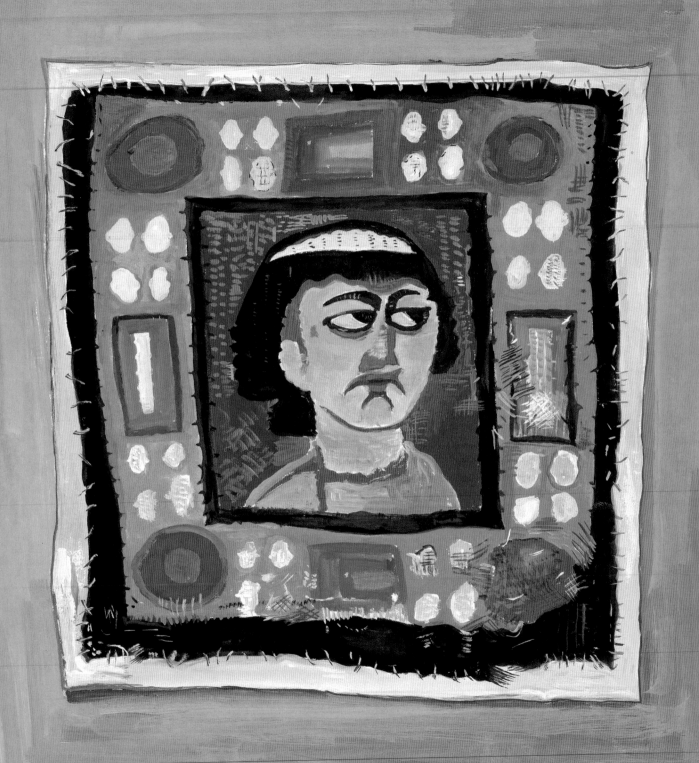

The OBJECTS

(with Digressions)

WE BEGIN with a PORTRAIT.
A PEEVISH FACE on a BIT of
Ancient Egyptian cloth.
A FROWN CAUGHT FOR ETERNITY.
You CAN Rely on SADNESS.
HAPPINESS, weLL... that is a different story.

I love CRAZY things,

CRAZILY.

I enjoy

tongs,

scissors.

I adore

cups,

rings.

soup spoons,

not to mention,

of COURSE,

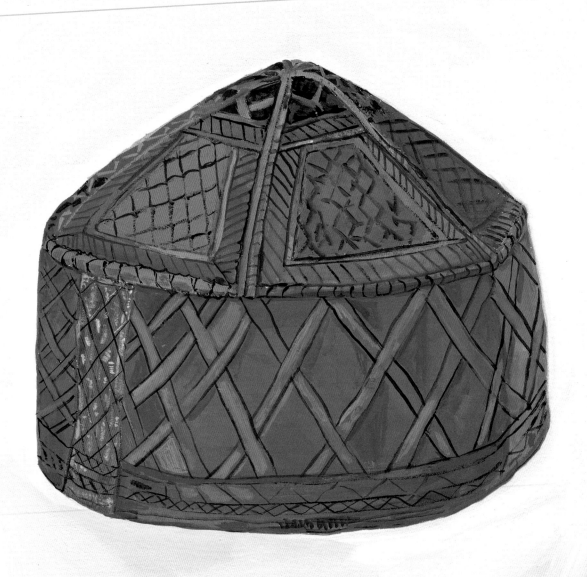

the HAT.

- PABLO NERUDA, "Ode to Things," 1959

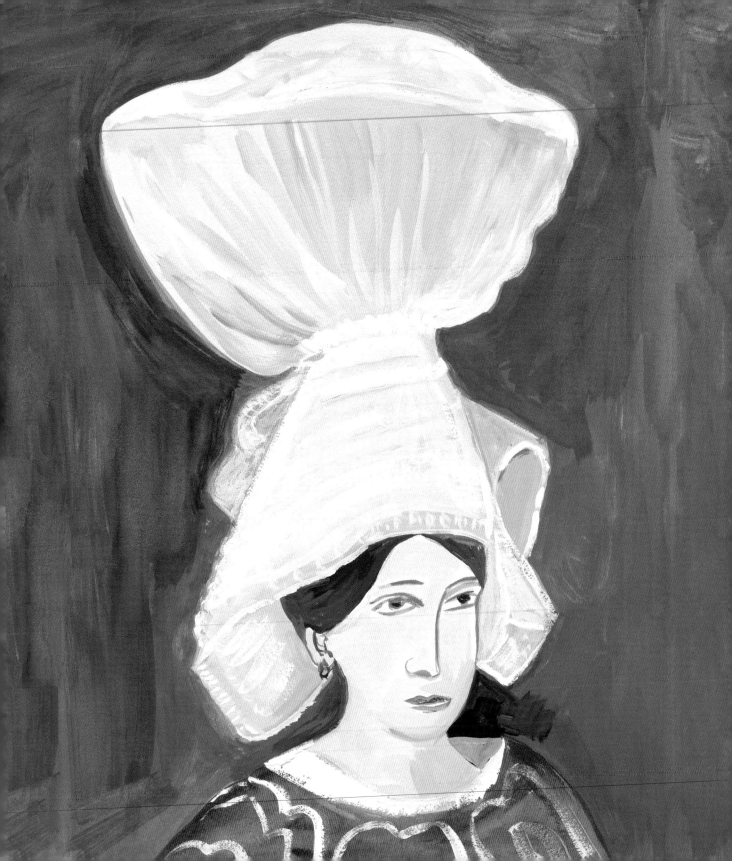

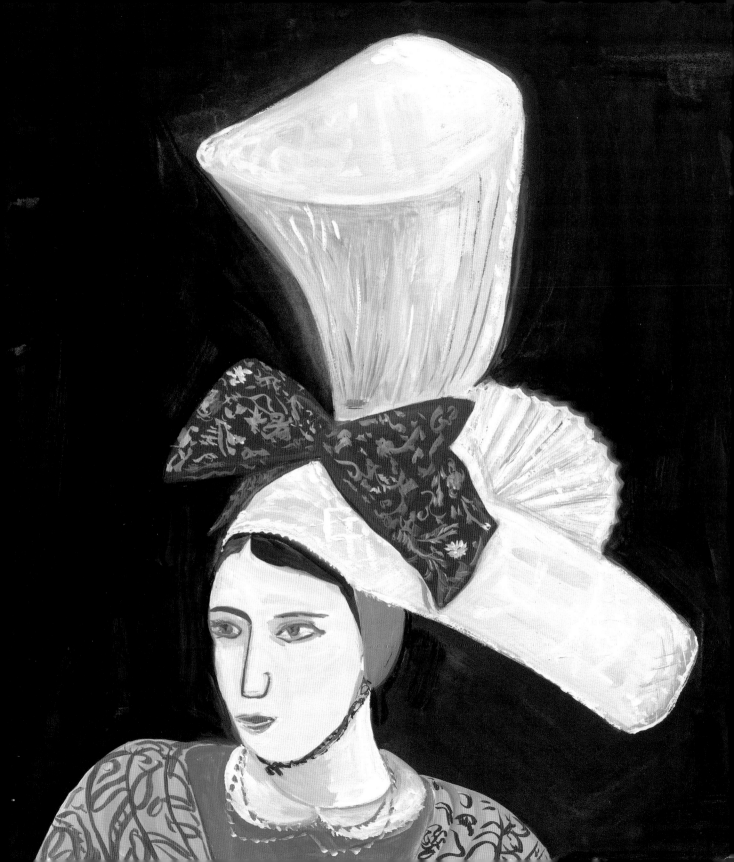

And don't forget

the

KYLIX.

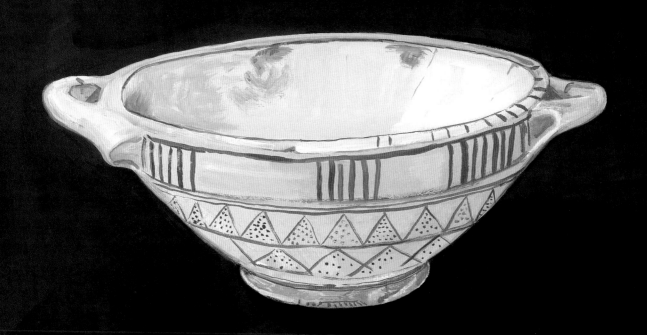

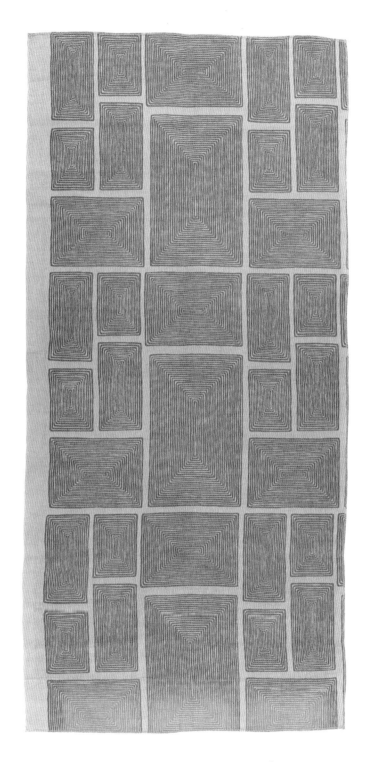

And the FABRIC.

And the
LOOPY
Kantharos.

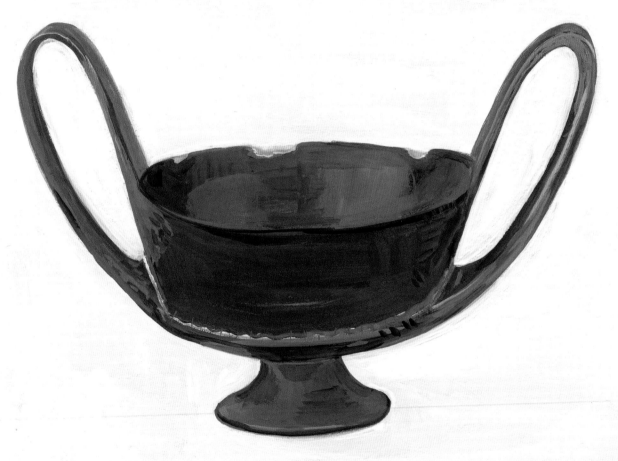

and the
EXALTED and
ANGULAR
Zig-Zag
chair.

And...

The
sensational
calligraphic
scribble

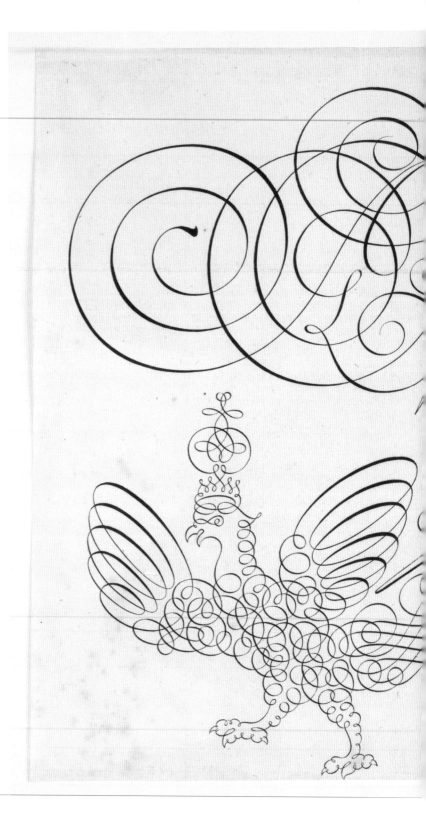

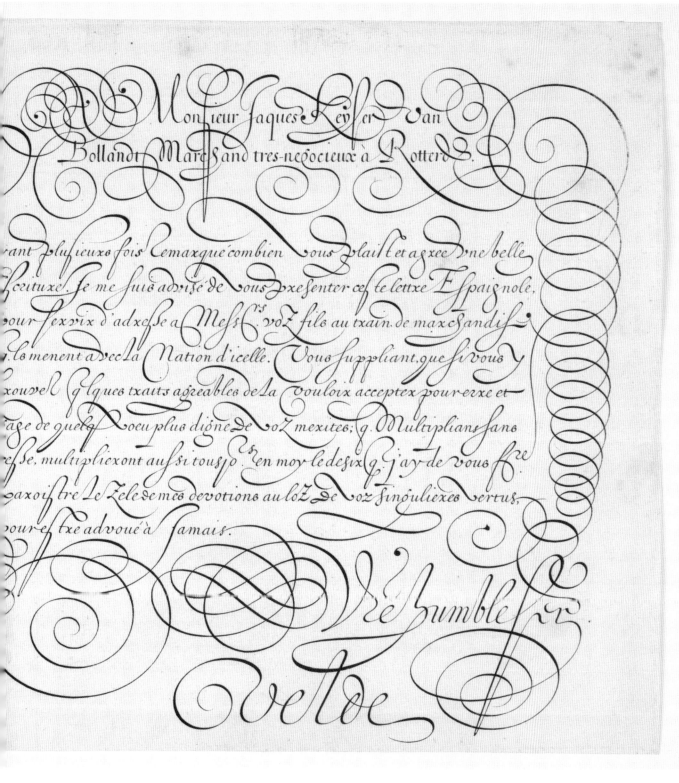

Monsieur Jaques Keyser van
Bollandt Marchand tres-negocieux à Rotterd.

ant plusieurs fois remarqué combien vous plaist et agree vne belle
Escriture. Je me suis advisé de vous presenter ceste lettre Espaignole,
pour servir d'adresse a Messrs voz fils au train de marchandise
qu'ils menent avec la Nation d'icelle. Vous suppliant, que si vous y
trouvez q'lques traits agreables de la vouloir accepter pour erre et
gage de quelq' voeu plus digne de voz merites; q. Multiplians sans
cesse, multiplieront aussi tousjors en moy le desir q. j'ay de vous
paroistre le Zele de mes devotions au loz de voz singulieres vertus,
pour estre advoué à Jamais.

Vre humble &c.

Velde

And here is another kind of SCRIBBLE.
The BRACELET SCRIBBLE.

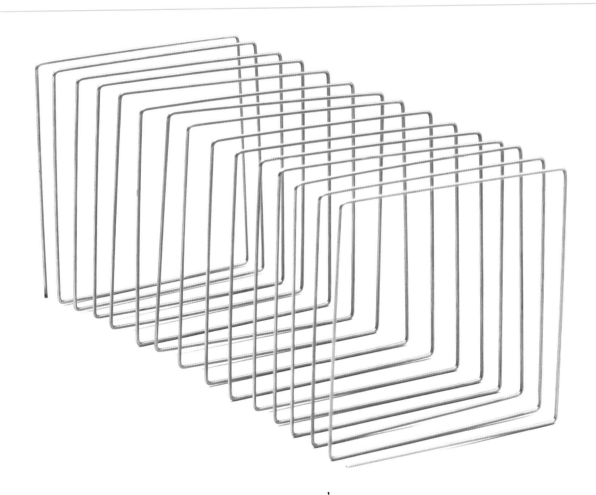

AFTER THE LOOPS AND LINES,
IT DOES NOT REQUIRE MUCH EFFORT TO
ARRIVE at the WORK OF FRED SANDBACK,
AN ARTIST WHO WORKED WITH SPACE and STRING.
IF you have a ROOM and YOU DiViDE
iT WiTH STRING, you HAVE ALL The
PARTS OF LiFE you COULD POSSIBLY NeeD.

50

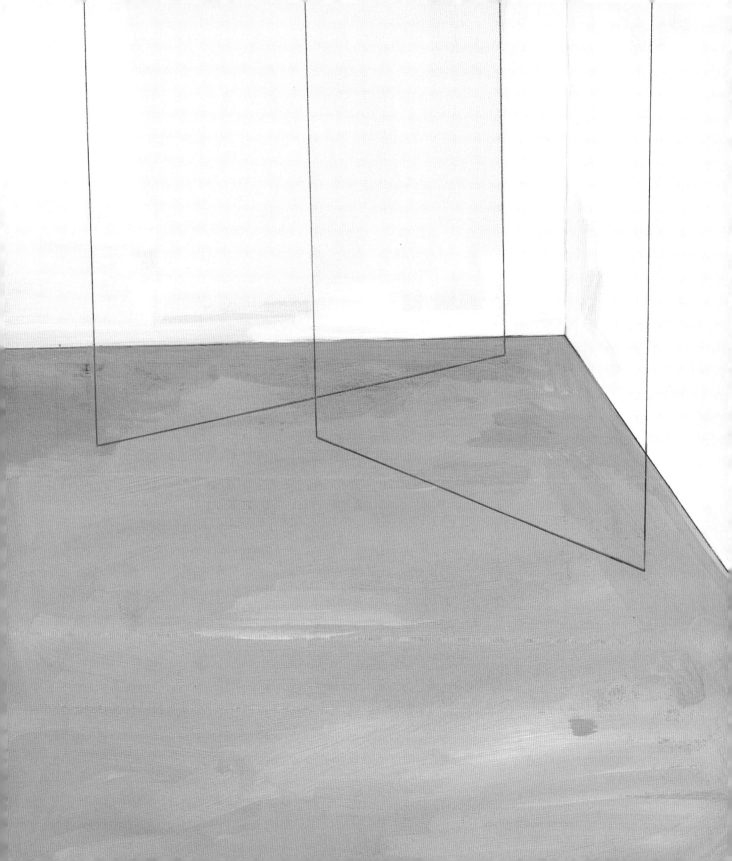

FROM THE LINE
IT DOES NOT TAKE
MUCH EFFORT TO
ARRIVE AT THE SCALLOP.

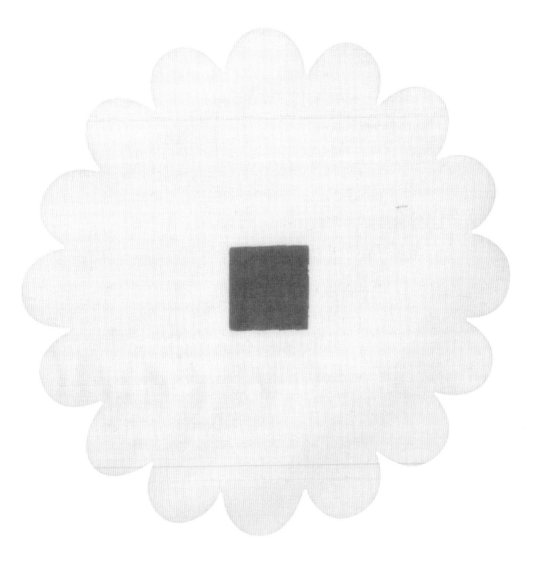

THE GIRL IN THE PINK SCALLOPED DRESS
WAS STANDING ON THE LAWN.

WHAT HAPPENS
WHEN you Stand FOR
A LONG TIME?
you get
TIRed.

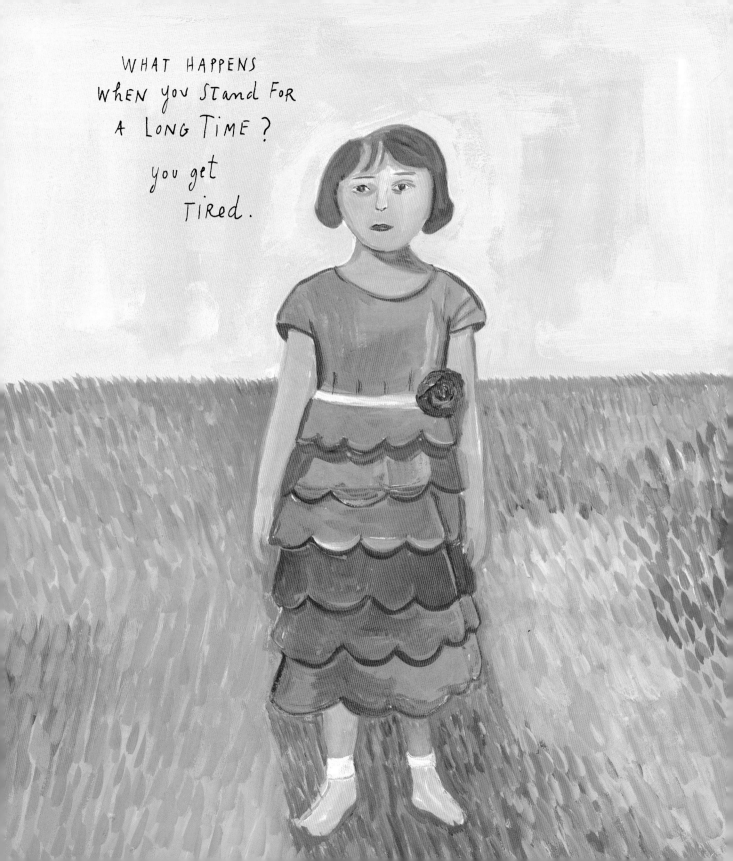

WHOEVER invented the BED WAS a GENIUS.
WHEN you GET UP FROM Bed, get DRESSED.
IN PANTS
And socks.

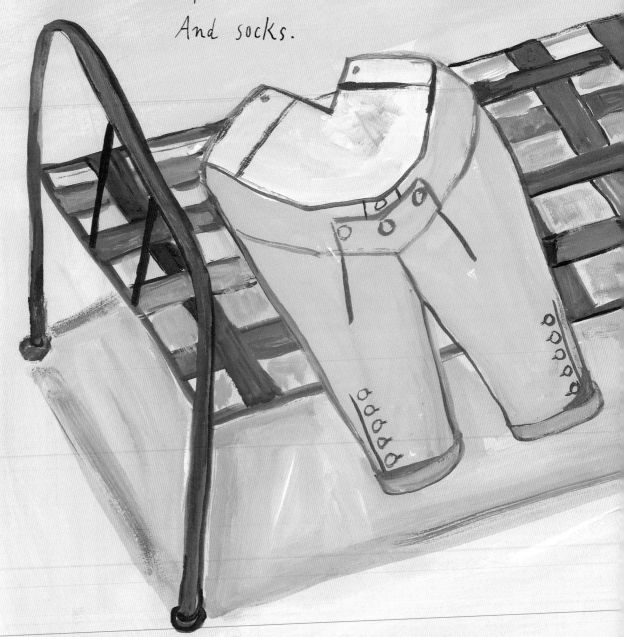

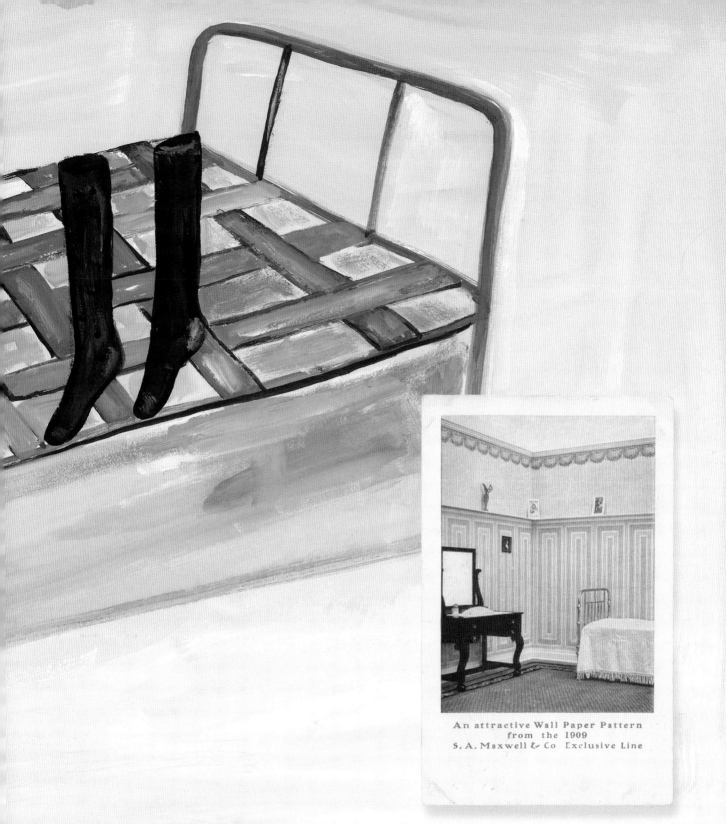

An attractive Wall Paper Pattern
from the 1909
S. A. Maxwell & Co Exclusive Line

AND SHOES.

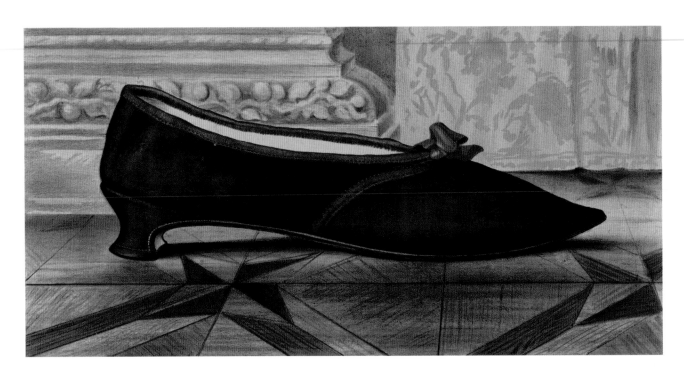

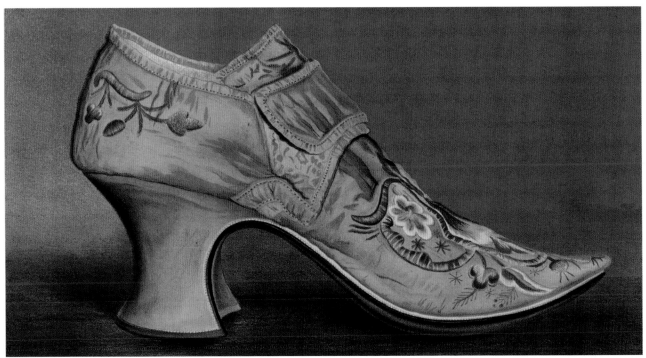

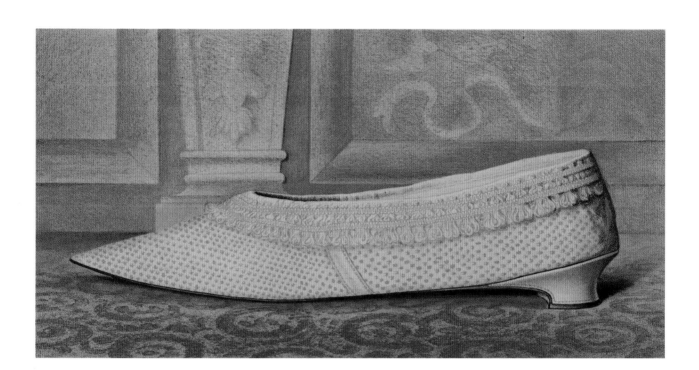

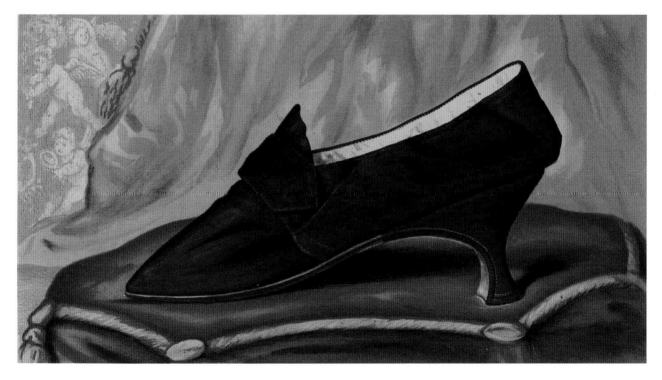

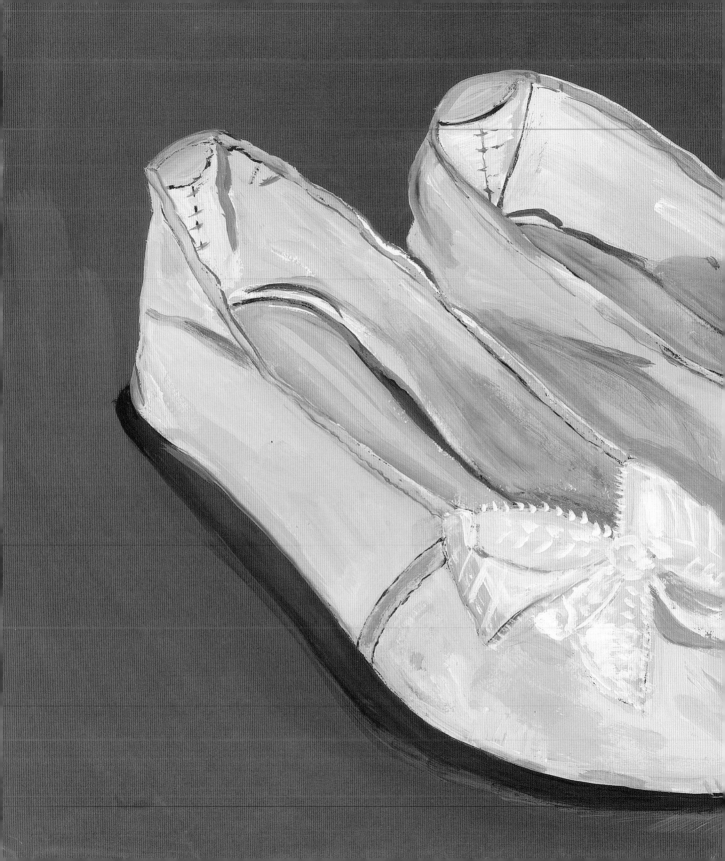

THE ABILITY TO TAKE a WALK from one
POINT TO THE NEXT point, that is half
the BATTLE won.

GO OUT and WALK.

That is the GLORY
of LIFE.

After taking
a WALK you
will probably
be hungry.
you will
want to EAT something.

"I would GLADLY PAy you TUESday for a hamburger today."
— Wimpy, FROM Popeye
by E.C. SEGAR, 1932

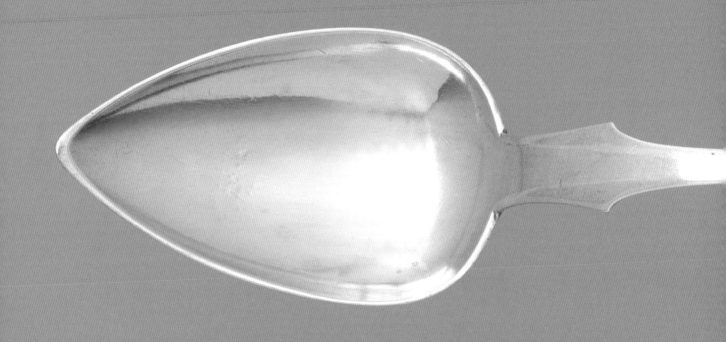

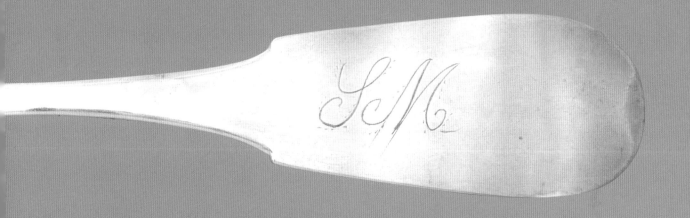

Before there were forks, there were spoons.
The SPOON can be used by a baby, by a person eating soup.
Watching a person eat soup can break your heart.

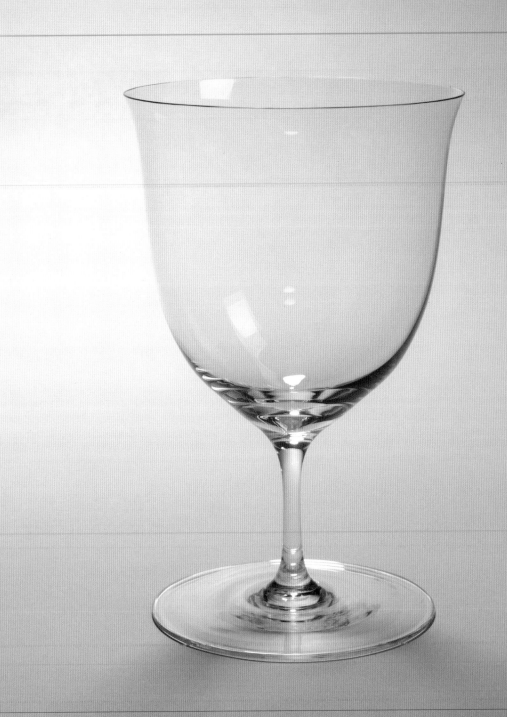

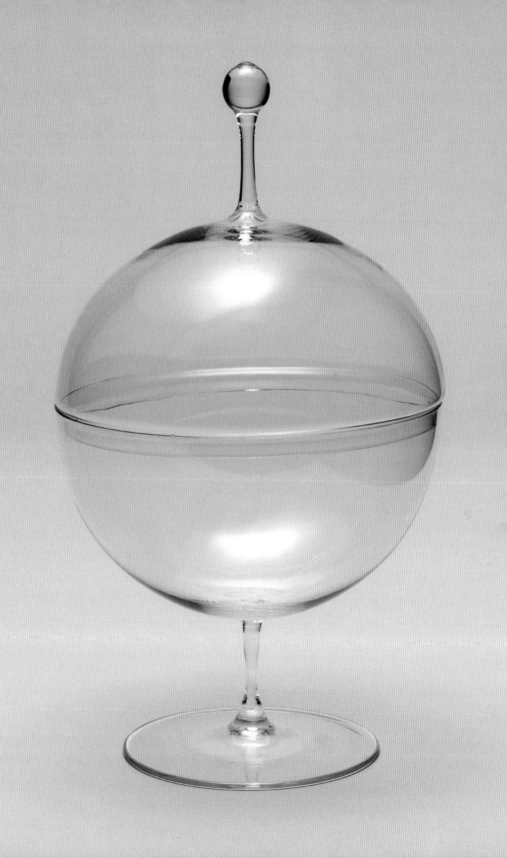

If you walk past the
window of a candy shop,
it is appealing to go inside.
The packaging alone is
worth it. There was
a time when candy
conjured up images of
ribbons and boxes and
tissue and ruby red foil.

The smell of cognac
and chocolate was part
of the smell of the
cabinet in my
aunt's house, or
maybe your aunt's
house.

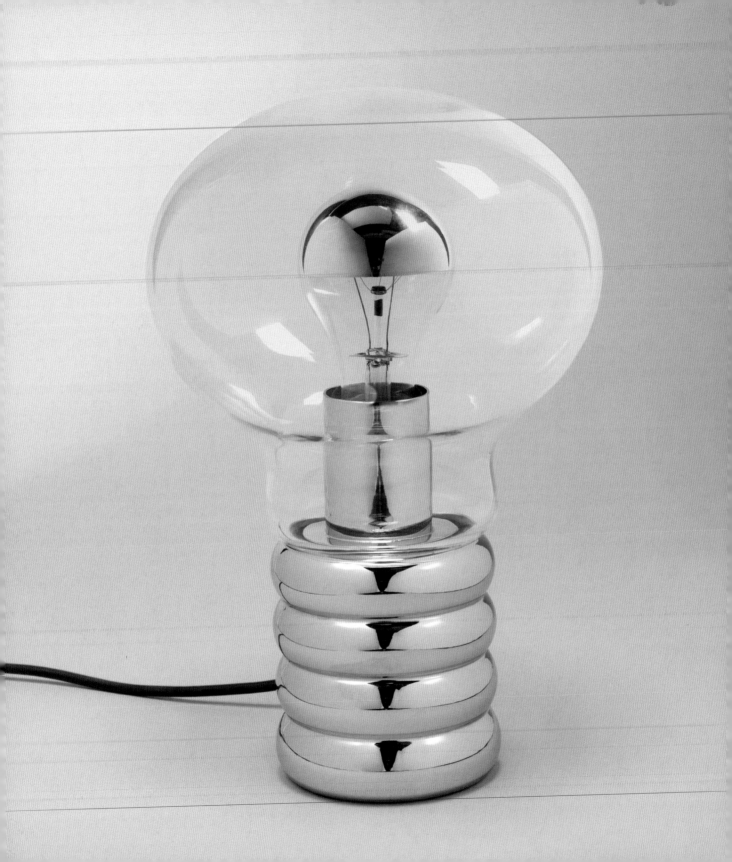

In the EARLY EVENING,
CARRying the BOX of chocolates,
in that somewhat MELANCHOLY
changing time between Day and Night,
we hurry home.

There is a lamp on a polished table.

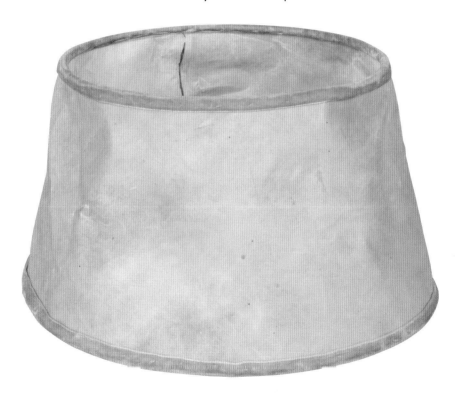

The LAMP is turned on.
gentle glow.

And we can Read a Book. The Book. Calming Object.
Held in the hand.

WINNIE ‑ THE ‑ POOH

BY

A. A. MILNE

DECORATIONS BY

E. H. SHEPARD

Alice's Adventures in Wonderland.

CHAPTER I.

DOWN THE RABBIT-HOLE.

ALICE was beginning to get very tired of sitting by her sister on the bank, and of having nothing to do: once or twice she had peeped into the book her sister was reading, but it had no pictures or conversations in it, "and what is the use of a book," thought Alice, "without pictures or conversations?"

So she was considering in her own mind (as well as she could, for the hot day made her feel very sleepy and stupid), whether the pleasure of making a daisy-chain would be worth the trouble of getting up and picking the daisies, when suddenly a white rabbit with pink eyes ran close by her.

There was nothing so *very* remarkable in that; nor did Alice think it so *very* much out of the way to hear the Rabbit say to itself, "Oh dear! Oh dear! I shall be too late!" (when she thought it over afterwards, it occurred to her that she ought to have wondered at this, but at the time it all seemed quite natural); but when the Rabbit actually *took a watch out of its waistcoat-pocket*, and looked at it, and then hurried on, Alice started to her feet, for it flashed across her mind that she had never before seen a rabbit with either a waistcoat-pocket or a watch to take out of it, and, burning with curiosity, she ran across the field after it, and was just in time to see it pop down a large rabbit-hole under the hedge.

The MARCH HARE took the watch
and LooKed at it GLOOMILY:

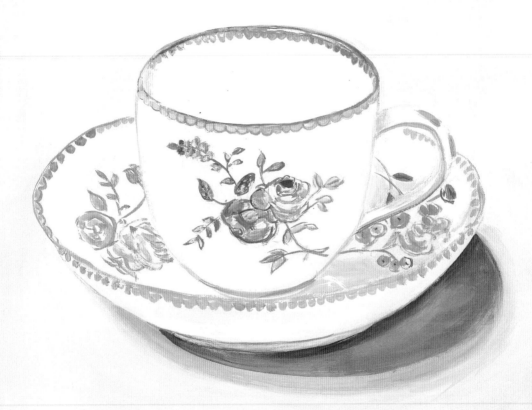

Then he dipped it into his cup of tea
and LooKed at it again
"Take some MoRe tea," the MARCH HARE said
to Alice, VERY earnestly.

"I've had Nothing yet," Alice Retorted in an offended tone: "So I can't take More."

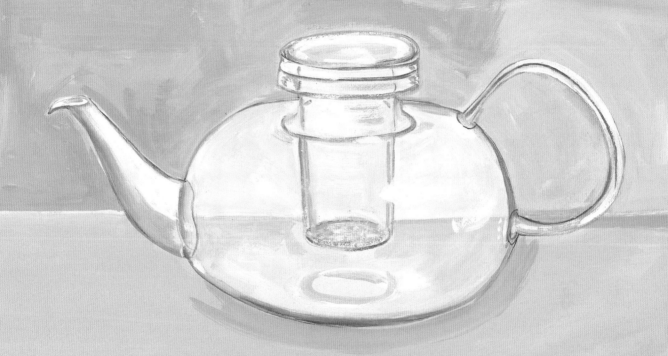

"You mean you can't take less," said the HATTER:

"it's very easy to take More than Nothing."

— Lewis Carroll
Alice's Adventures in Wonderland, 1865

Alexandra "XIE" Kitchin
and her BROthers
George, Hugh, and Brook.
Photograph by
Lewis CARROLL,
JUNE 1875

THINGS TO REMEMBER.

1. Always keep your hands and face clean.

2. Wash your hands before you eat.

3. Do not eat in a greedy manner like a pig.

4. Never slam the doors; go quietly up and down stairs; never make a loud noise in the house.

5. Avoid three things, a pouting face, angry looks, and angry words.

6. Be kind to your brothers and sisters.

7. Do as your parents bid you, always. Do nothing that your parents would dislike.

8. Never hurt a bird, or a dog, or a hen, or a goose, or a frog, or a toad, if you can help it.

9. Be kind and gentle to all living things.

10. Remember that God made all creatures to be happy; and do not you prevent their being so, without good reason for it.

HOW TO COUNT.

Do you know how to count? Begin.

One	Eleven
Two	Twelve
Three	Thirteen
Four	Fourteen
Five	Fifteen
Six	Sixteen
Seven	Seventeen
Eight	Eighteen
Nine	Nineteen
Ten	Twenty

How many fingers have you on one hand?
How many fingers on both hands?
How many ears has a cat?

The BOOK.

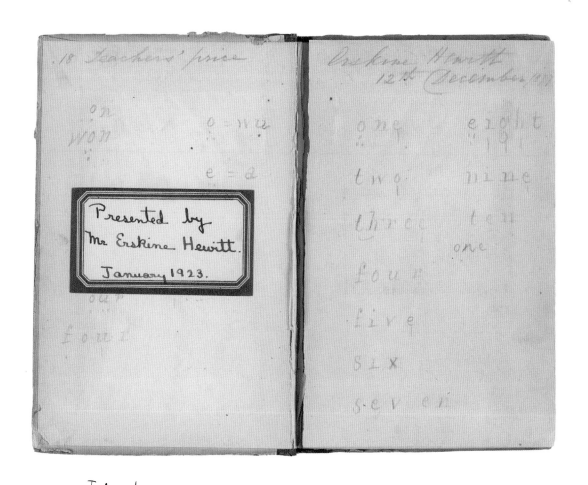

The dESign of thE PAGE.
LettERfoRMS.
PapeR.
TvRning pages. MaRKing youR PLace.
With what? A postcard? A bookmark fRom
a hotel in India? Reading. FoRgetting.
NumbERs on the PAGE.

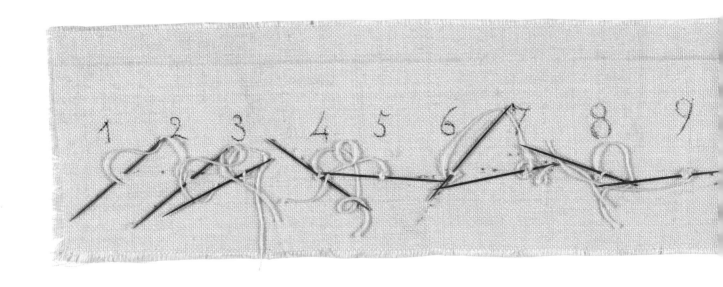

76

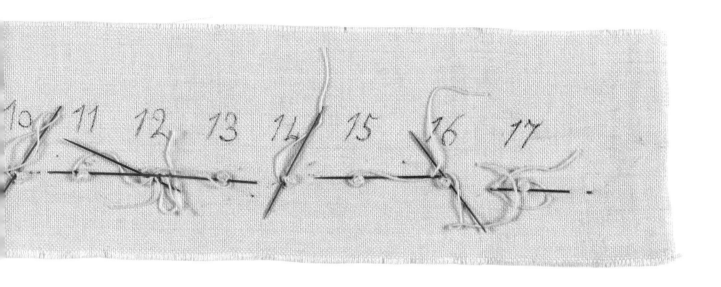

Numbers everywhere.

3

UNITED PICKLE

There is NO Reason to save tickets and STUBS.
They are tiny and inconsequential.
But I do save them and remember
that NumbER twenty-three was fRom
the coat check at the RESTaurant where
I ate the LEMON TaRT. The NUMBER is so
Elegant and honest. And the LEMON taRT
was So GOOD.

0280
CHECK

23

272

88

18

42

3

1
1

10
PIECES

2535

YOUR
NUMBER
30
WHEN CALLED
IT'S YOUR TURN
FOR SERVICE

13.
KALMAN

JEREMIAH

DRAPER'S

Book

1800

Penmanship.
Pens. Pencils. Nibs. Ink. Erasers.

Jeremiah Draper. 1800
Jeremiah Draper's 1800
Jeremiah Draper's 1800
Jeremiah Draper's 1800
Jeremiah Draper's 1800
Jeremiah Draper's 1800
Jeremiah Draper's 1800
Jeremiah Draper's 1800
Jeremiah Draper's 1800
Jeremiah Draper's 1800
Jeremiah Draper's 1800

If my name was Jeremiah Draper, I too would write it over and over again.

Packages.

One day I came Home and a WHITE BOX
WAS on My BEd. The Box contained a DRESS.
A dress of white Dotted Swiss with
PALE BLue DOTS.

Once I bought a box of Bracelets
as a gift.
The BOX was pink and tied with string.
It is Now the BOX that will NEVER be OPENed.

OVER the YEARS I have Received GIFTS
and given gifts. VARIOUS BOOKS and
BOXES have Been Tied with
RIBBON and STRING.

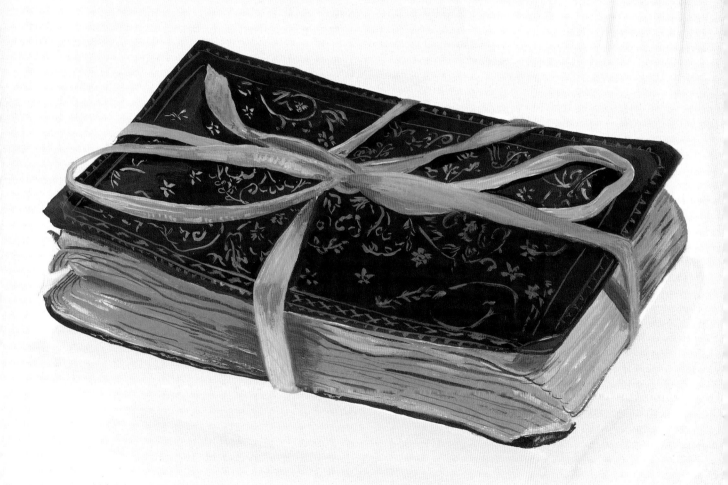

And then there are declarations of Achievement.
Certificates. Seals of Approval. HONORS.
DECORATIONS.
What can we do with them?
Put them UNDER the Bed or
behind the door?
Yes. Behind the DOOR.

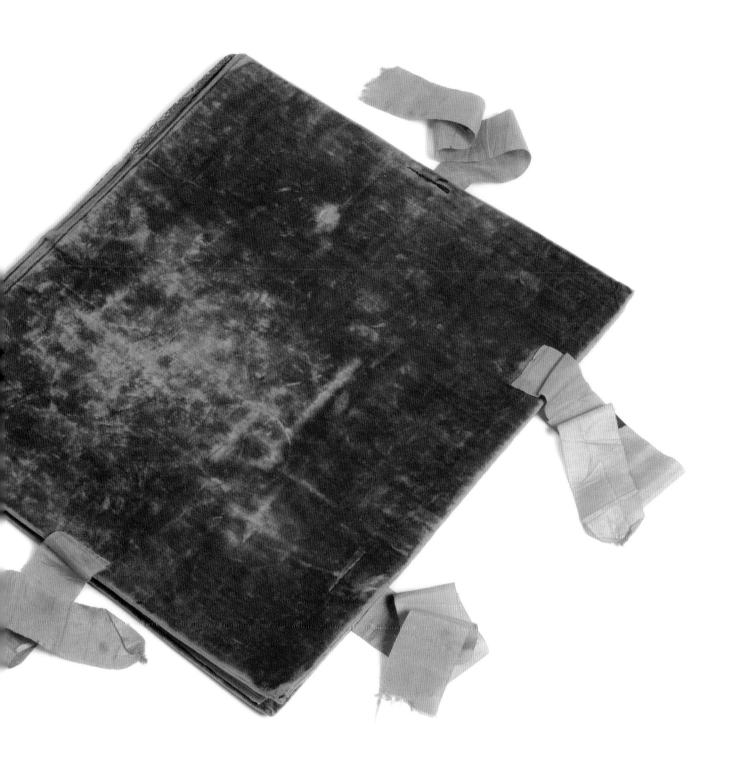

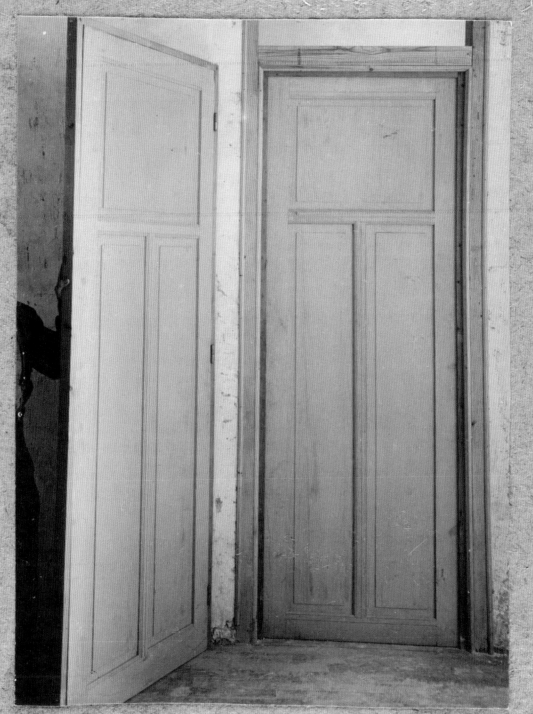

1951-160-2-47

DOORS (OF COURSE).

"My life shows that I KNOW OR am certain
that there is a CHAIR OVER THERE,
OR A DOOR, and so on. — I tell a
friend e.g.: 'TAKE that chair over there,'
'shut the DOOR,' etc., etc."
 — Ludwig Wittgenstein
 On CERTAINTY, 1969

I don't KNOW what kind of Certainty
he is talking about, but really,
what can you be certain of?
What is absolute? The ground
NEVER stops shifting.

The ARTIST Charlotte Salomon
lived in this Room in BERLIN
in the 1930s.

She painted and wrote about
her family in a book called
Opera or LIFE.

People were always
coming and going and dying.
She was killed in the Holocaust.

Which brings us inevitably
to SORROW.

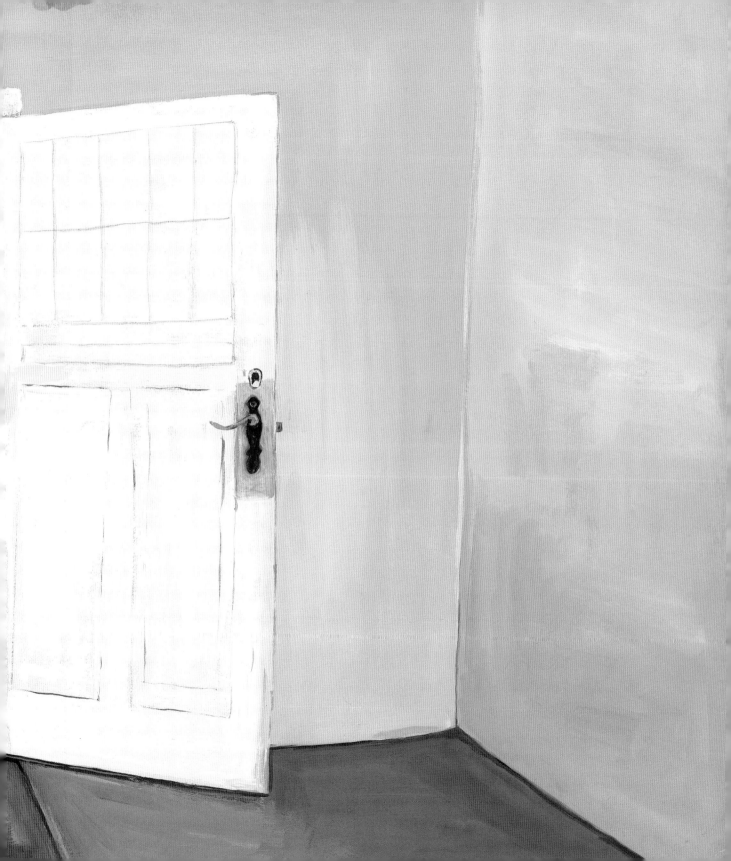

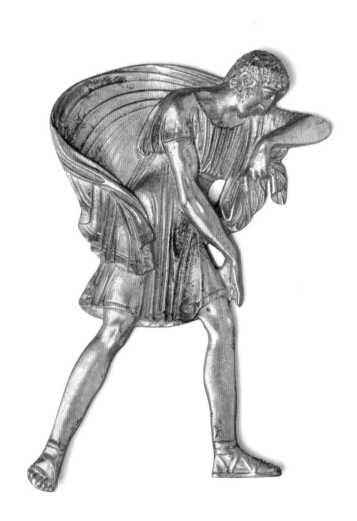

Head, Heart

Heart weeps.
Head tries to HELP Heart.
Head tells heart how it is, again.

You will lose the ones you love. They will all go. But even the EARTH will go, Someday.

HEART FEELS Better, then.

But the words of head do NOT Remain long in the EARS of HEART.

HEART is So NEW to this.

I want them BACK, says HEART.
Head is all heart has.
HElp, head. Help HEART.

—Lydia Davis, 2007

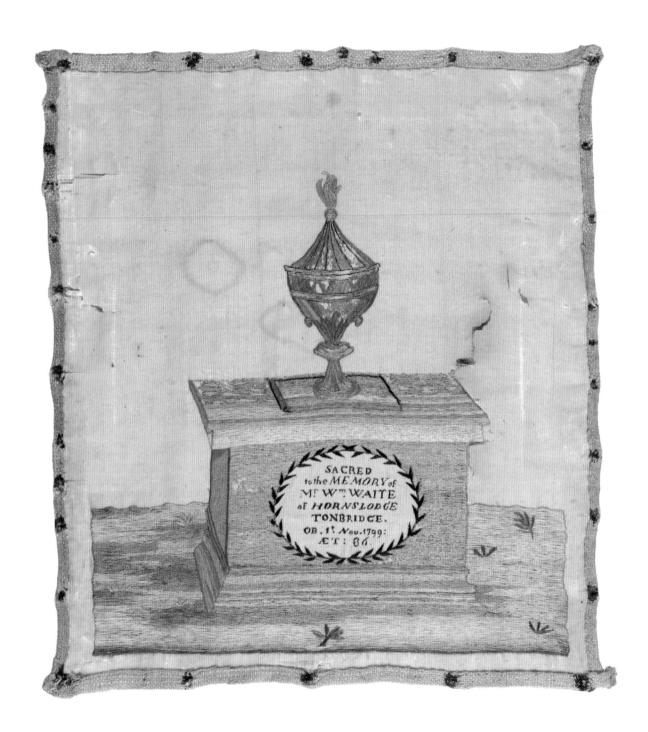

SACRED
to the MEMORY of
Mr Wm WAITE
of HORNSLODGE
TONBRIDGE.
OB. 1st Nov. 1799:
ÆT: 86

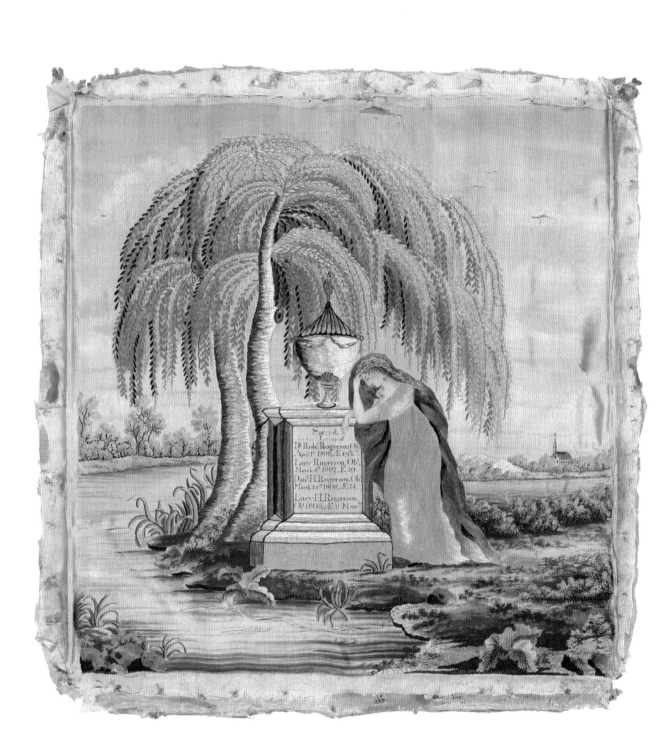

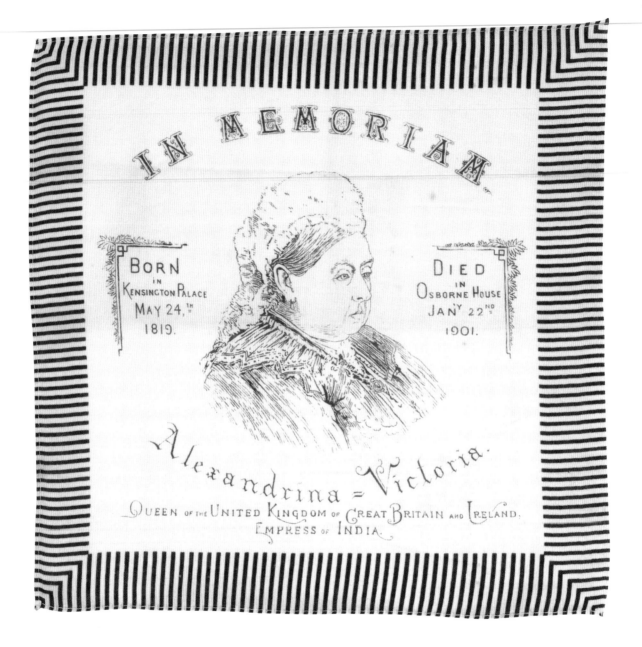

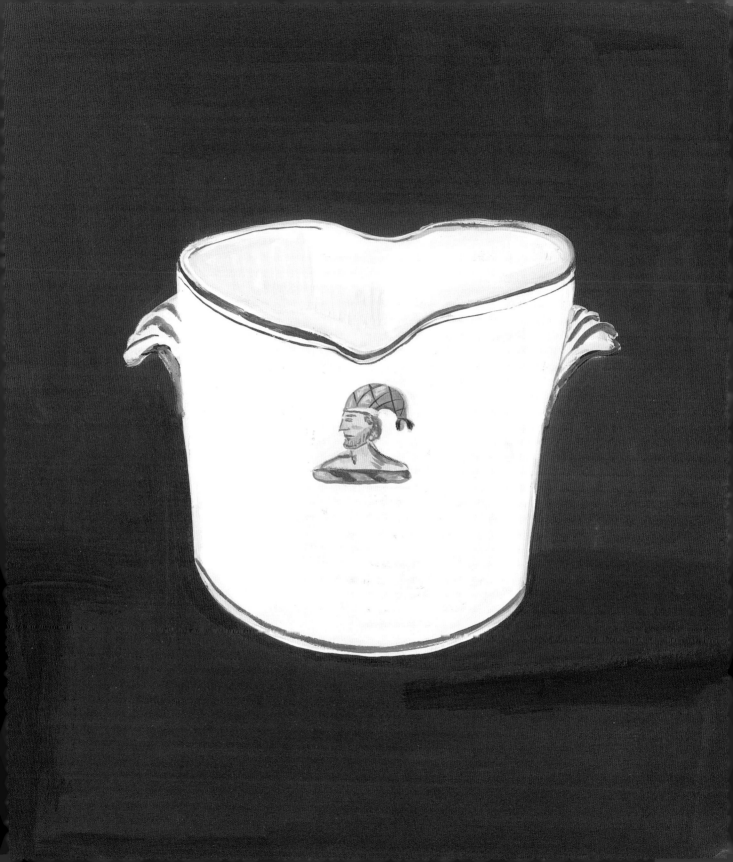

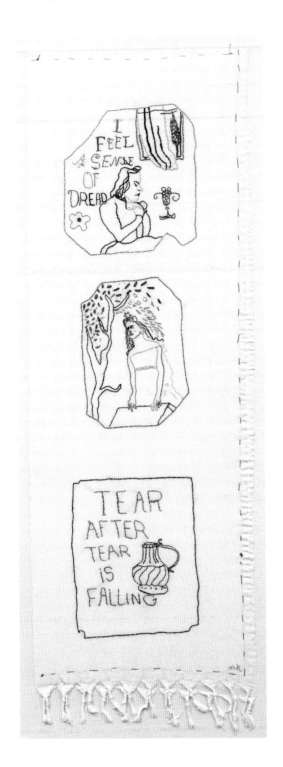

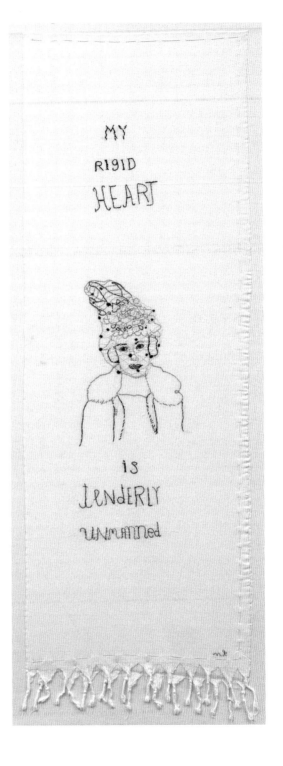

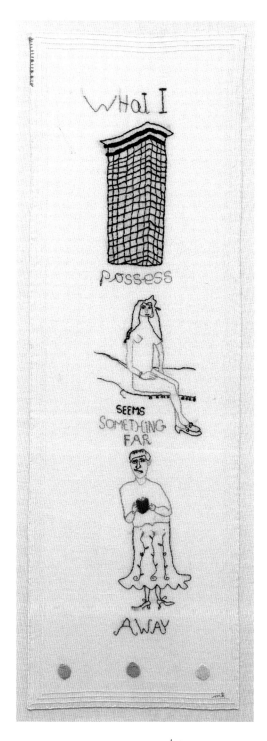

WHAT I

POSSESS

SEEMS
SOMETHING
FAR

AWAY

THE
I.R.q.d
River

THE woods

and

WHAT

HAD

disappeared

PROVES

REAL

When my mother died, I embroidered these pieces.
It is not possible to miss her LESS.

Abraham Lincoln died on April 15, 1865, at 7:22 a.m.,
four days after the end of the CIVIL WAR.
He was fifty-six years old.

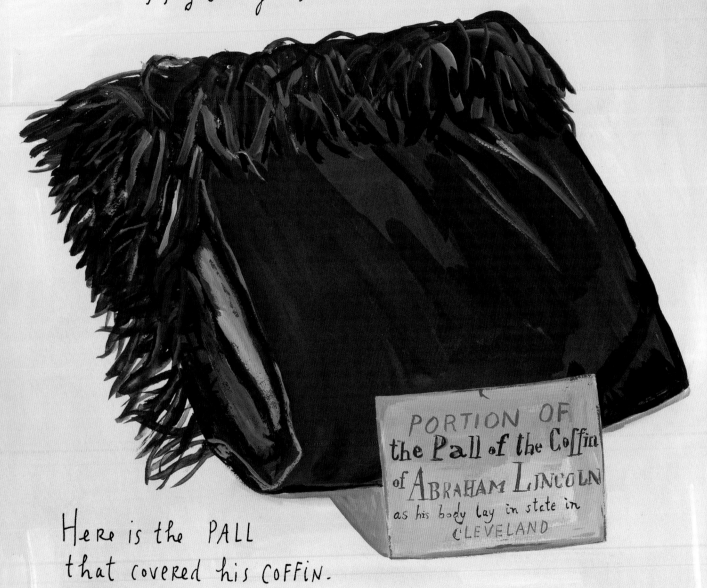

PORTION OF
the Pall of the Coffin
of ABRAHAM LINCOLN
as his body lay in state in
CLEVELAND

Here is the PALL
that covered his COFFIN.
 Adding fringes WAS a DECISION someone had to MAKE.

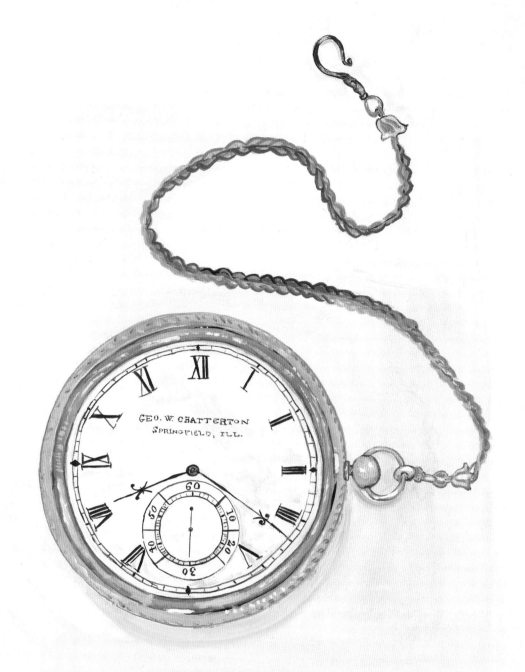

This was his pocket watch.
In 2013, the watch was cleaned and
it ticked for a few minutes.

Criandose ✦ un gusto .

Por dos ✦ fieles .

Una ✦ hermanesa .

Y una ✦ los sostiene .

En este ✦ yace .

Un ✦ que ha sufrido .

De amor la ✦ dura .

Y la ✦ del olbido .

A B C D E F G H Y J K L M

M N O P Q R S T V Z

vivimos felices

Amor nos

Para Matilde Thompson

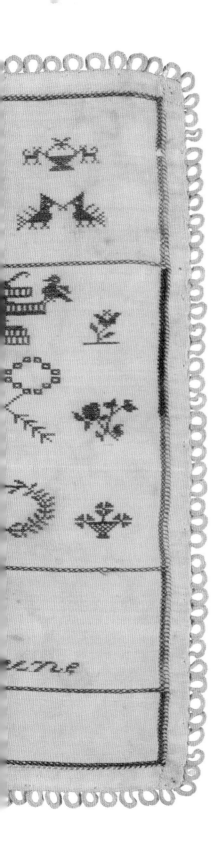

Here is the final object from the museum.

A sampler made for a young girl called Matilde.

Amor nos une.

"Love unites us."

Full stop.

The Museum closes in
the EVENING.

And everyone goes home
to their BOXES OF CHOCOLATES

OR BOOKS

OR LITTLE BITS OF THIS and THAT.

And Now what?

PART III

CODA, OR SOME OTHER THINGS THE AUTHOR COLLECTS AND/OR LIKES

Naps under trees.
BLURRY thoughts.
Breaths.
Angry thoughts.
Breaths.
Trees.

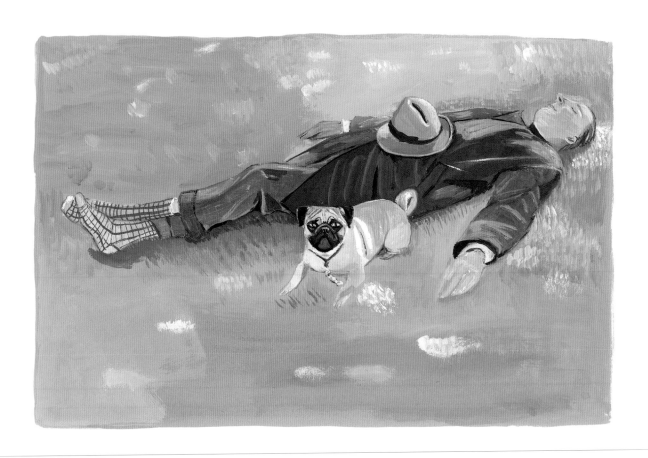

Beds.

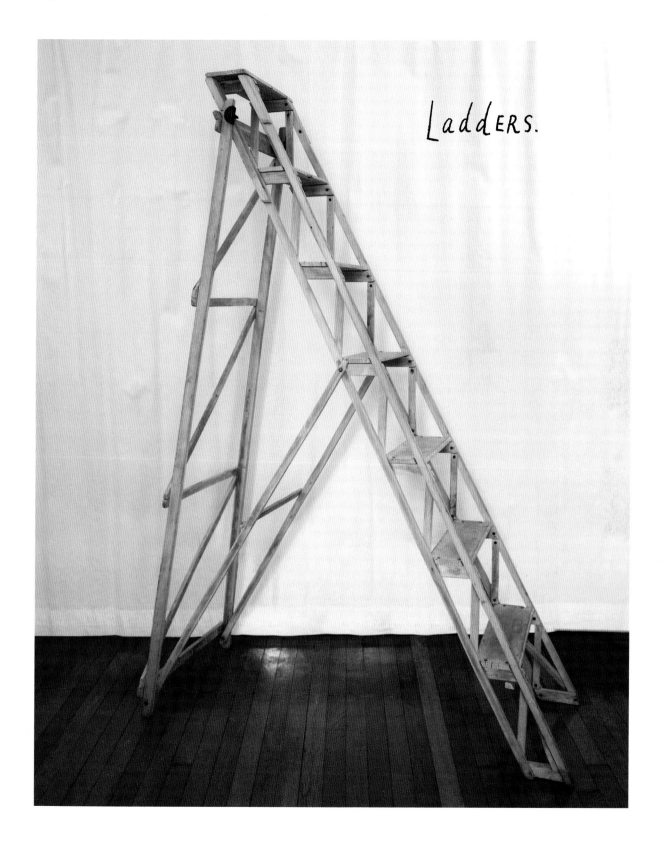

Ladders.

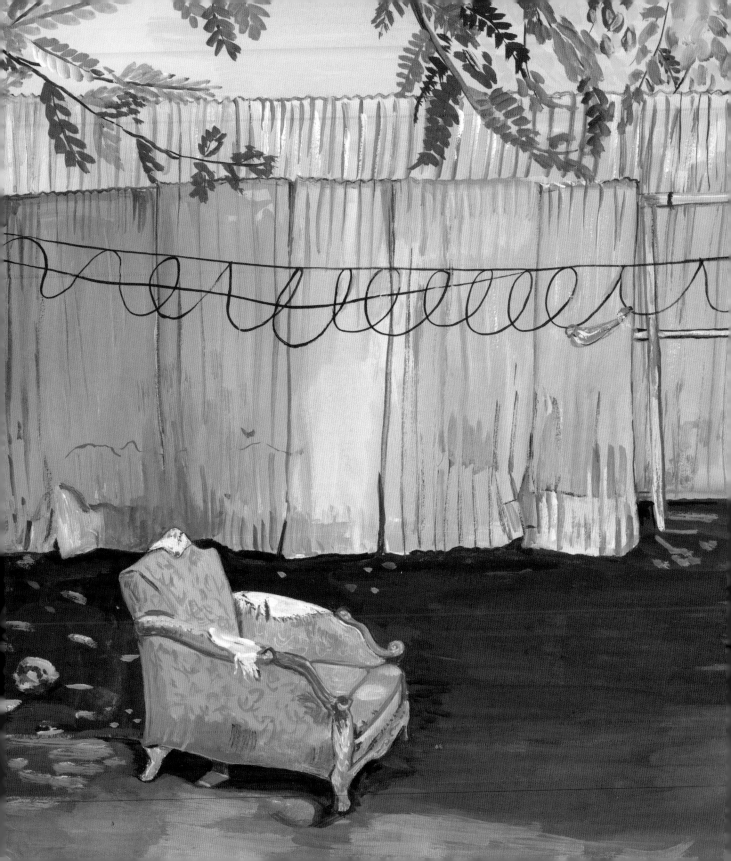

BROKen Chairs.

There are so many Broken chairs all around.
To be Striding along and come upon a
Broken chair on the Street is like
getting a TERRIFIC PResent.

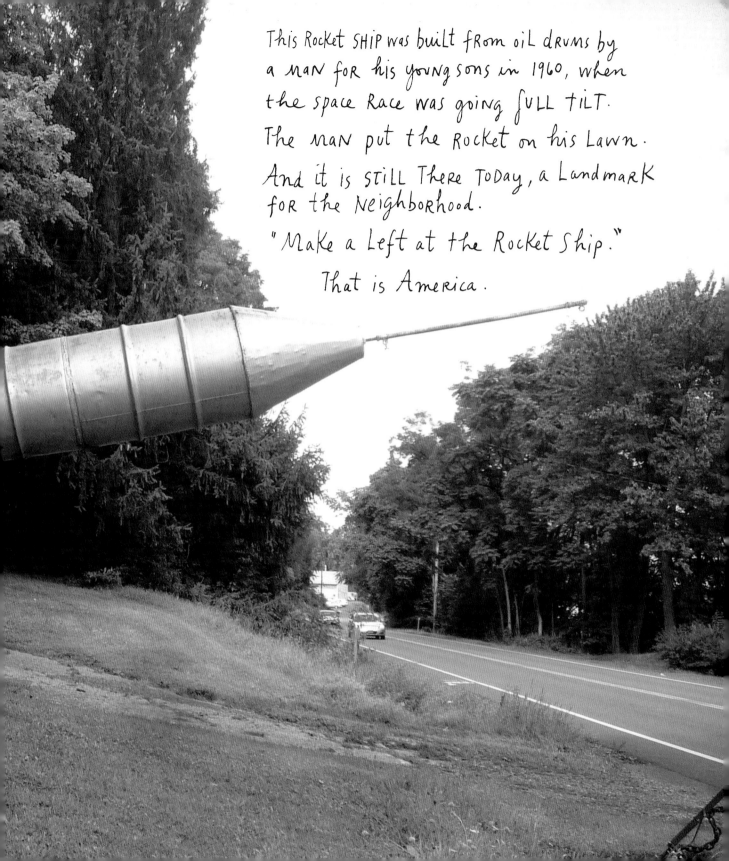

This Rocket SHIP was built fRom oiL dRums by a maN foR his young sons in 1960, when the space Race was going fULL tiLT.

The maN put the RocKet on his Lawn.

And it is STiLL TheRe ToDay, a LandmaRK foR the NeighboRhood.

"MaKe a Left at the RocKet Ship."

That is AmeRica.

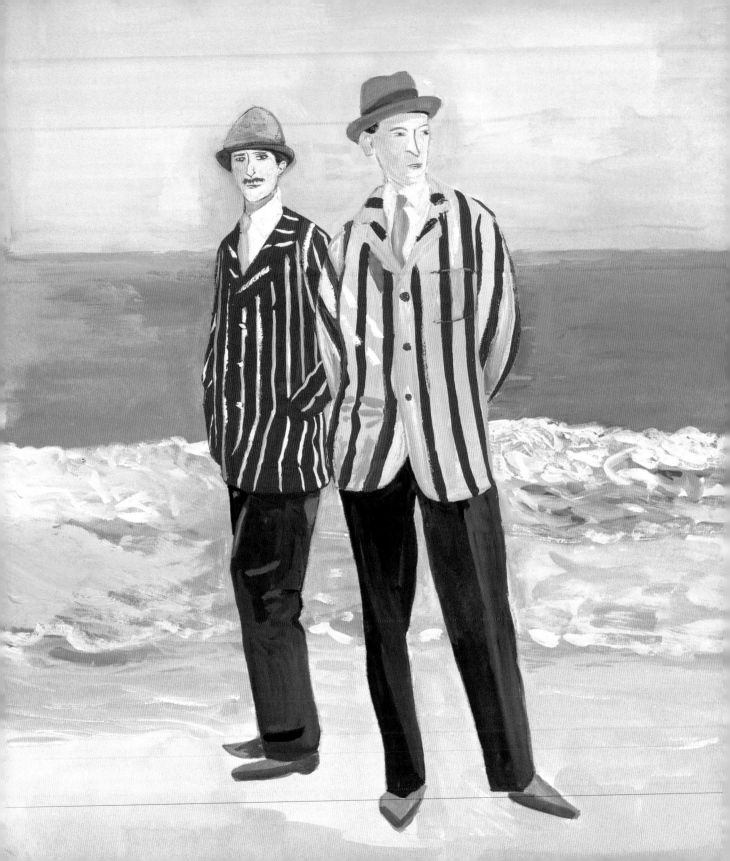

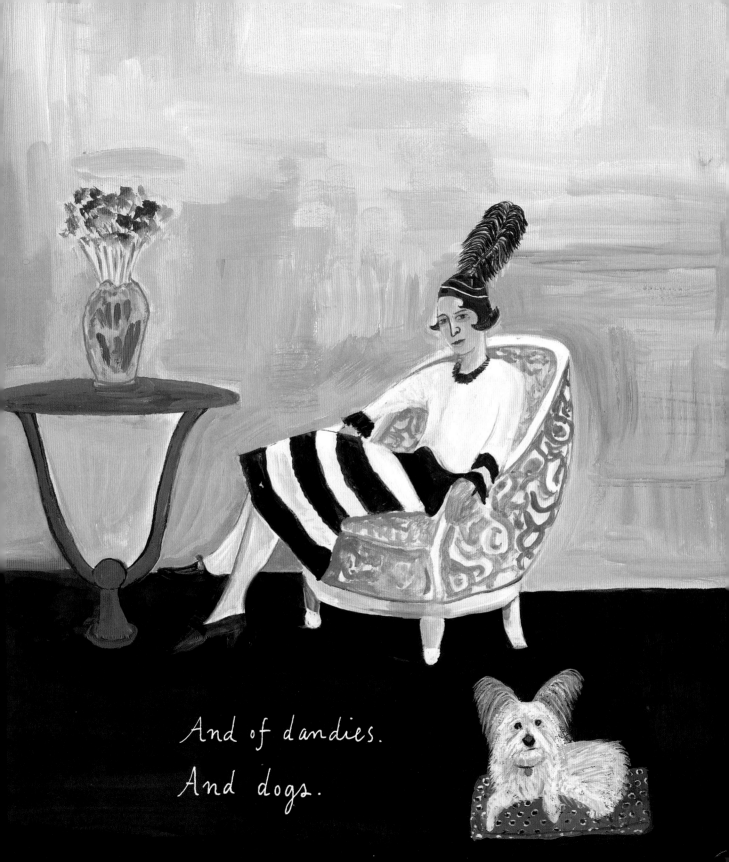

And of dandies.
And dogs.

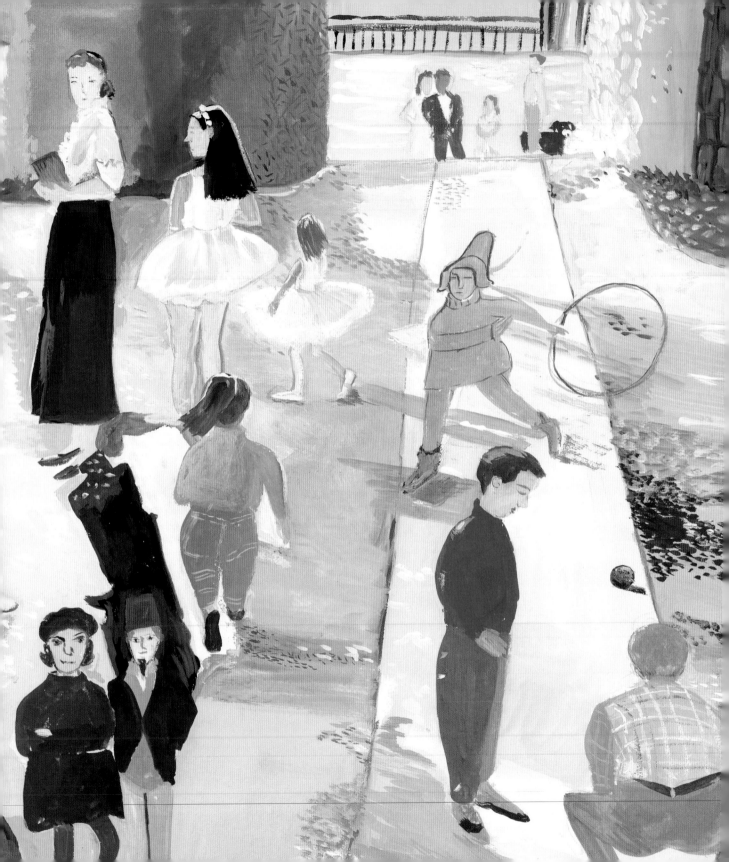

People caphured mid-moment.

AND CHAIRS
BALANCING
CHAIRS.

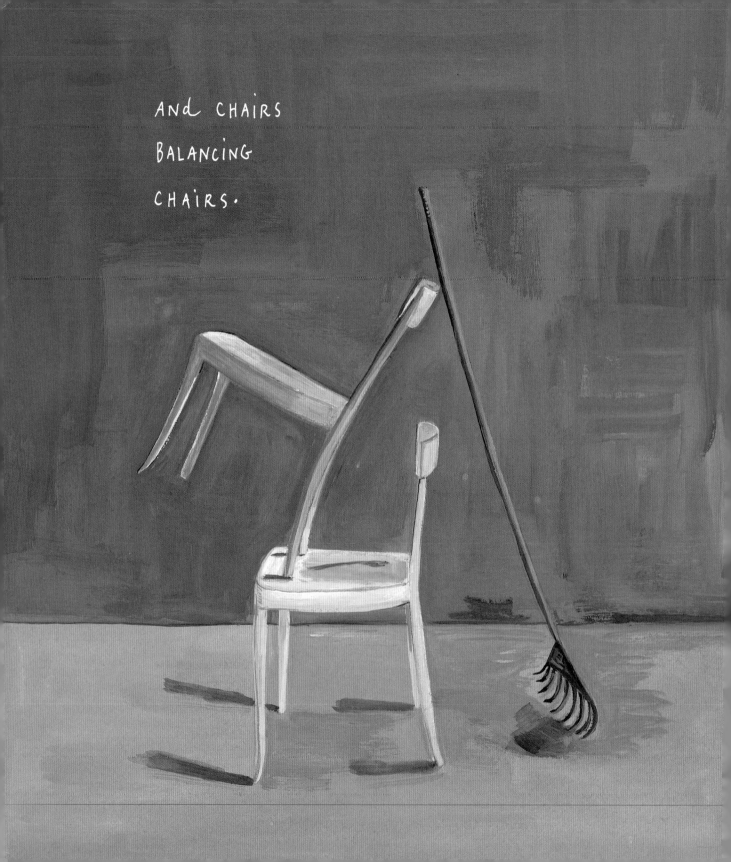

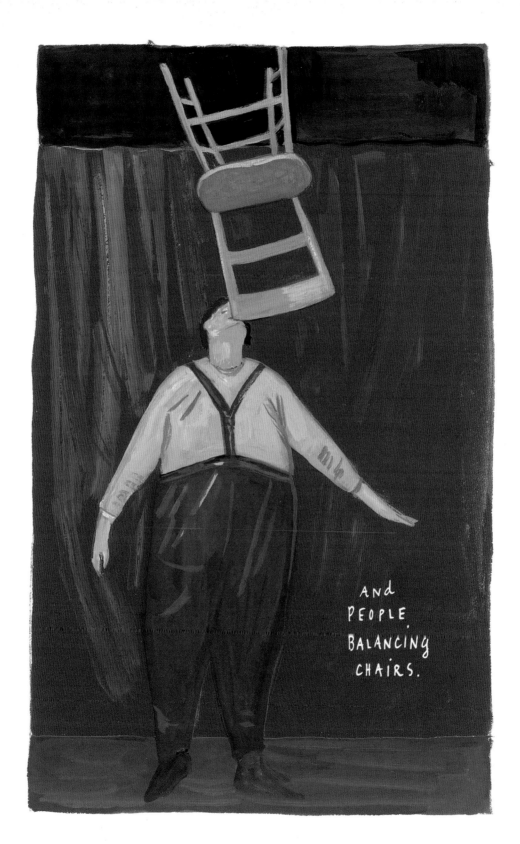

AND
PEOPLE
BALANCING
CHAIRS.

And angELS
waLKiNg
aWAy
FRom me.

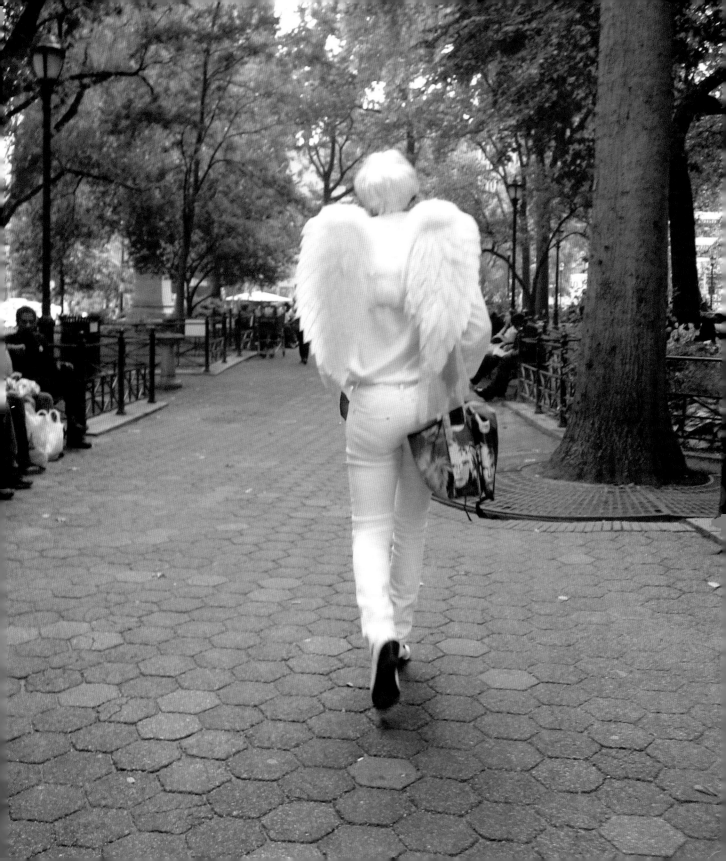

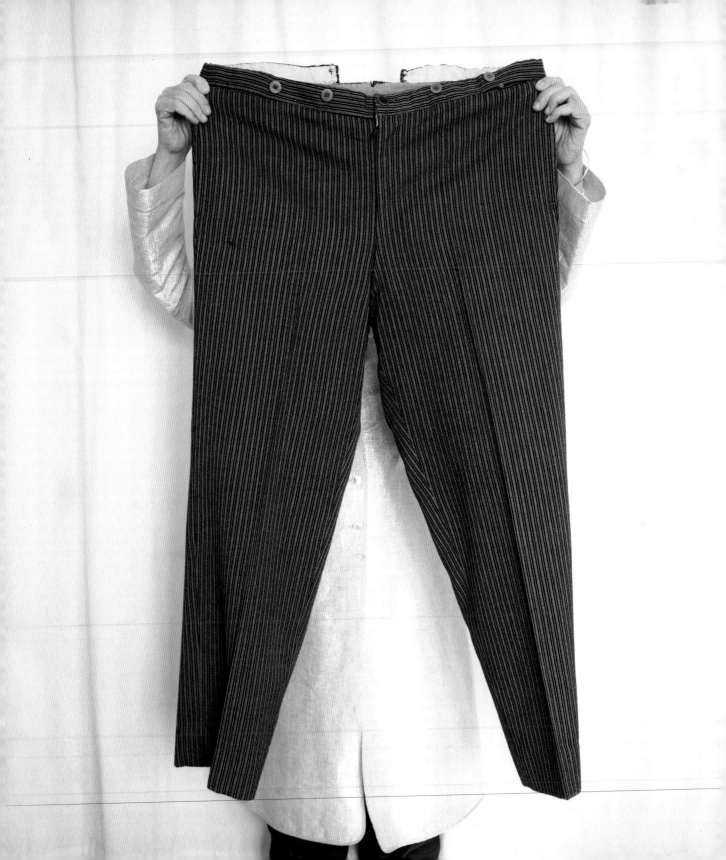

I COLLECT
PANTS of FAMOUS dead CONDUCTORS.
Well, ONE pair of pants of ONE dead ORCHESTRA CONDUCTOR.

ARTURO TOSCANINI was born in PARMA, Italy, in 1867.
 He conducted the fledgling Israel Philharmonic
(then called the PALESTINE PHILHARMONIC) in 1936.
He WORE thESE PANTS TO Rehearsal with the
orchestra. I won the pants at auction
in New York City in 2013.
 (IF TOSCANINI had met my mother in Tel Aviv
 in 1936, he would have fallen madly in love with heR.)

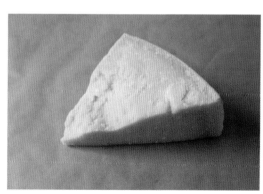

Here is a Parmesan Cheese,
also from Parma.

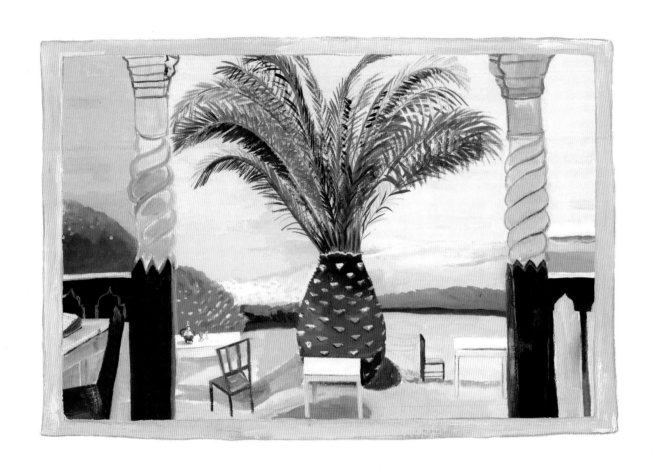

I COLLECT POSTCARDS FROM
the Hotel Celeste in Tunisia.

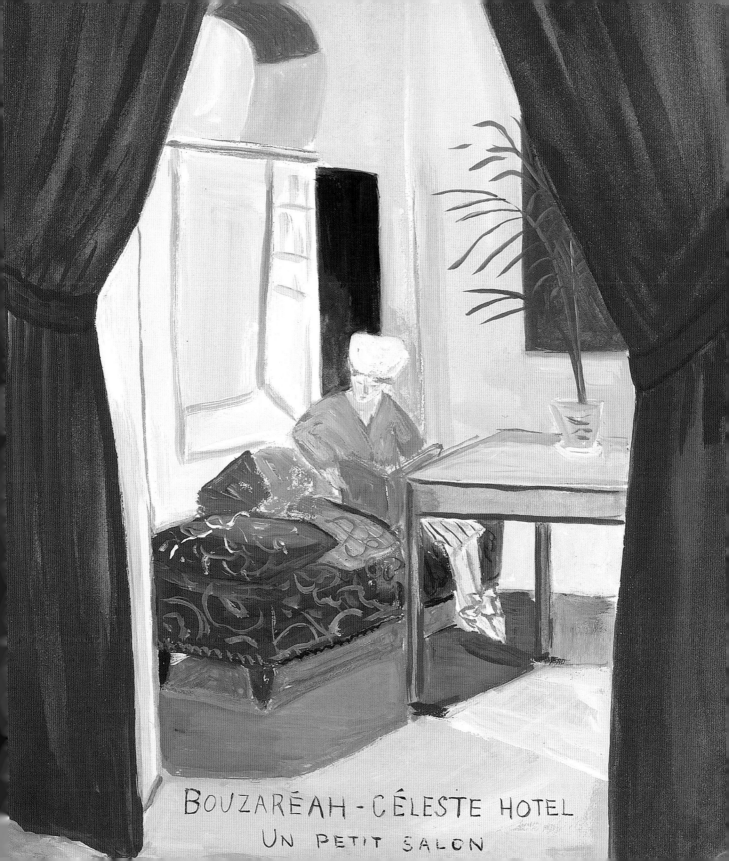

BOUZARÉAH - CÉLESTE HOTEL
UN PETIT SALON

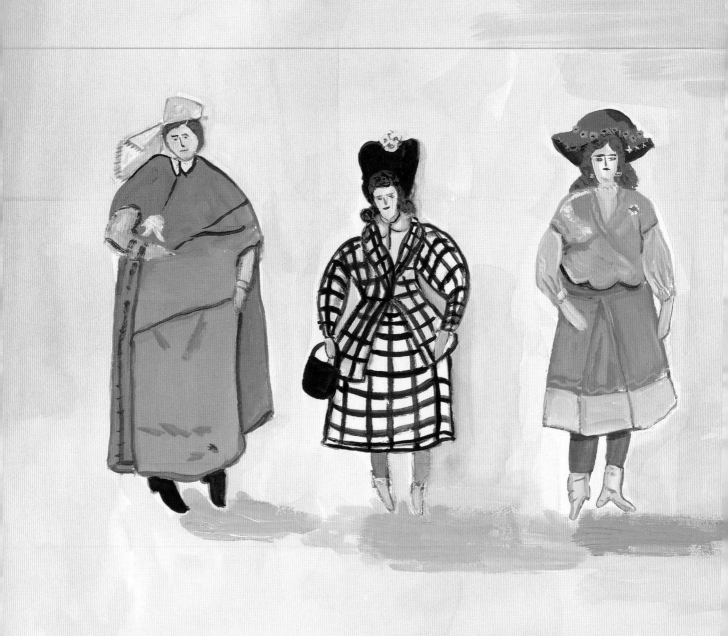

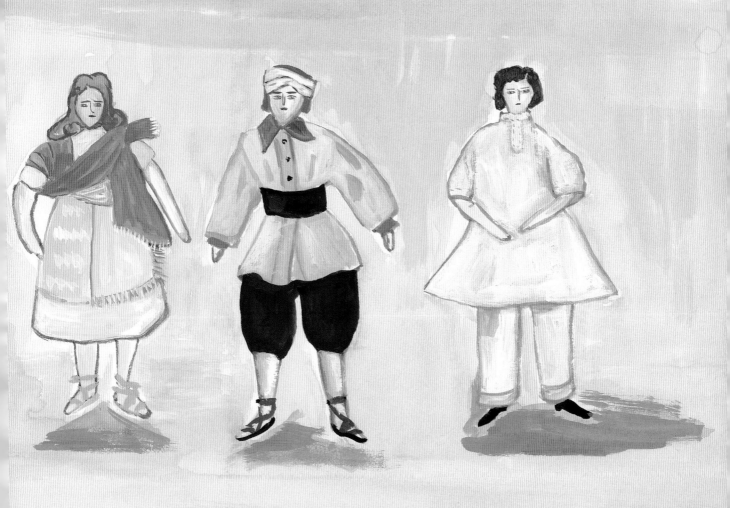

DOLLS made by NUNS in a
convent in Mexico.
The NUNS have sensational fashion sense.

BATHTUBS.

BUTTONS.

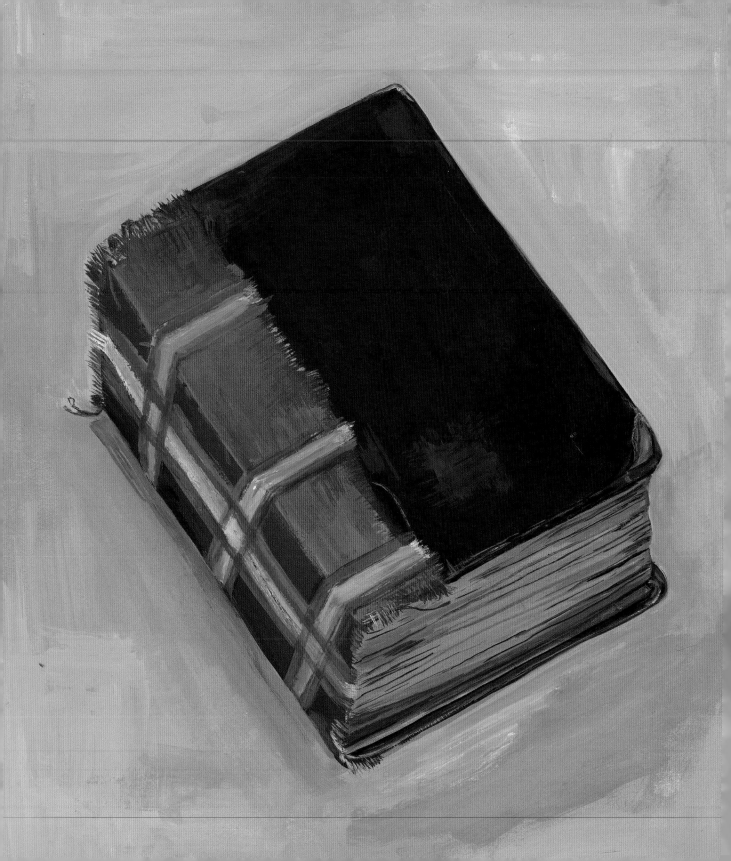

And BOOKS.

COMPLAINTS.

But I am very Poorly Today & very stupid
& HATE EVERYBODY and EVERything.
One Lives ONLy to MAKe BLunders. —
I am going to write a Little BOOK
for Murray on Orchids
& today I HATE them
worse than EVERything.
So Farewell & in a Sweet
Frame of mind
 I am
 Ever yours.

C. Darwin

— The Correspondence of
Charles Darwin, Vol.9, 1861

Names in Part I of the Idiot
by Fyodor Dostoevsky

Mr. Pavlishtchev
Madame Epanchin
General Epanchin
Nikolay Andreyevitch Pavlishtchev
Prince Lyov Nikolayevitch Myshkin
Parfyon Rogozhin
Semyon Parfenovitch Rogozhin
Vassily Vassilitch Konyov
Semyon Semyonovitch
Nastasya Filippovna Barashkov
Lebedyev
Barashkov
Afanasy Ivanovitch Totsky
Alexander Lihatchov
Armance
Coralie
Princess pAtsky
Lihatchov
Salyozhev
Andreyev
Seryozha Protushin
Ivan Fyodorovitch Epanchin
Alexandra Adelaida
Aglaia
Gavril Ardalionovitch Ivolgin
Dr. Schneider
Lizaveta Prokofyevna
Abbot Pafnuty
Pogodin
Nina Alexandrovna
Ferdyshtchenko

Varvara Ardalionovna
Ivan Petrovitch Ptitsyn
Kolpakov
Ardalion Alexandrovitch
Princess Byelokonsky
Biskup
Dr. Pirogov
General Sokolovitch
Kulakov
Alexandra Mihailovna
~~Madame Mihailovna~~
Madame Terentyev
Marfa Borissovna
Mytovtsov
Ippolit
Kinder
Trepalov
Darya Alexeyevna
Marya Semyonovna
Nikifor
Platon Ordyntsev
Anfisa Alexeyevna
Petya Vorhovsky
Countess Sotsky
Sofya Bezpalov
Katerina Alexandrovna
Madame Zubkov
Sevely
Zalyozhev

Lists.

Madame Bovary 1.

 green cloth
 black buttons
 red wrists
 blue stockings
 yellow trousers
 loud colors
 red ink
 yellow, violet or blue
 red sun
 black dots
 grey top-knots
 blue wax
 dark violet stains
 vast gray surface

 2.
 blue wool
 blue merino dress
 white skin
 blue eyes
 whiteness of her nails
 although brown, they seemed black
 green paint
 a white turned-down collar
 black folds
 rose-colored
 scarlet
 black gloves
 silk the color of pigeons breasts
 white skin
 a little black shawl
 gray stockings

 3
 touched with blue
 white cotton stocking
 white dress
 great white beaming faces
 red dabs
 colored scarf
 green corn
 black coat
 yellow cream
 blue cardboard
 green field
 all white
 gold bands
 rosy face

 canary yellow paper
 white calico curtains
 red border

 4
 red drapery
 white satin ribbons
 black in the shade
 dark blue in
 old white
 red fruit

 azure borders
 green fields
 white plume
 black horse
 golden wings

 white dress

 5
 white breeches
 black curtain
 white excoriations
 steel-grey ground
 rose-colored wings
 blue silken curtains
 black velvet coat
 long green cords
 whitened with the feathers of the pillow
 yellow butterflies
 white frock
 a green light
 the sky showed red between the branches
 brown colonnade
 a background of gray gold

 6.
 green-sward
 clusters of green along the curve of the
 gravel path
 gold frames
 black letters
 green cloth
 great black squares
 red-coated shoulders
 brown hair
 red claws of lobsters
 white cravat
 black ribbon
 seemed to her whiter and finer
 her black eyes
 blue luster

LETTERS.

My Dear Madame,
I just noticed that I forgot my
cane at your house yesterday;
Please be good enough to give it
to the bearer of this Letter.

P.S. Kindly pardon me for
disturbing you; I just
found my cane.

Marcel Proust

A Letter written to the Comtesse de Clermont-Tonerre from Marcel Proust

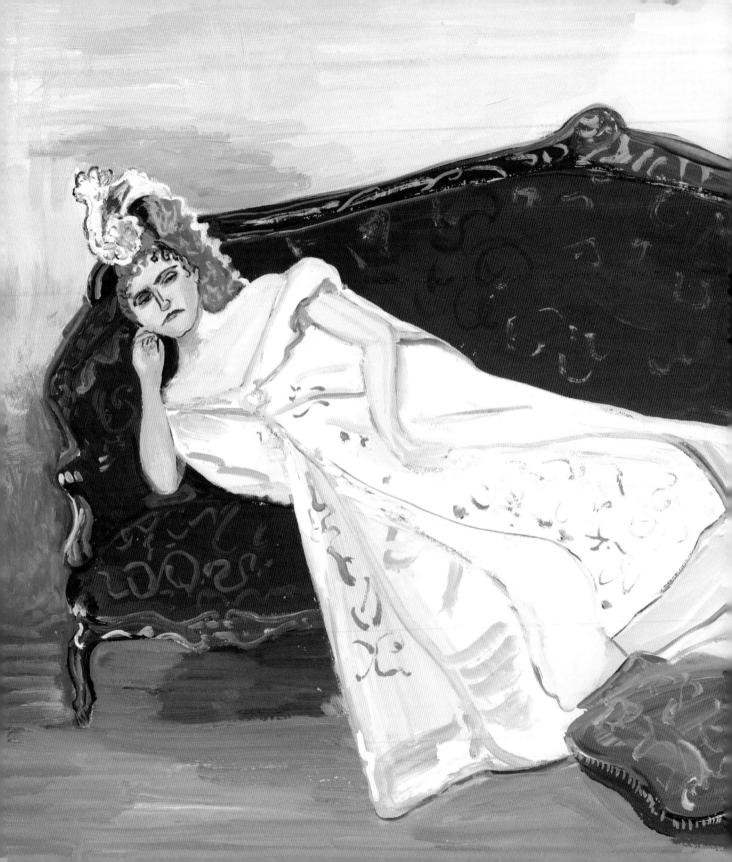

Here is another Countess.
The Countess of Castiglione.

I cannot take my eyes
off her.

So exhausted. So broken.

And maybe not.

Happy and sad.

Hopeless and Hopeful.

~~We are alivese~~ alive.

~~End of story.~~
We are alive and that
is ~~Glorious~~.
 All we have.

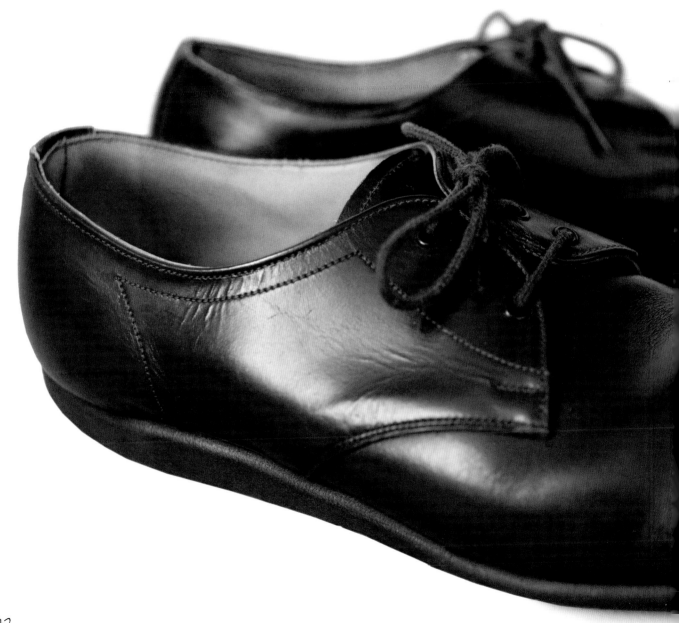

Here are the shoes that slow down time.
While visiting Vita Sackville-West's Sissinghurst Castle garden in the county of Kent, England, I went to a thrift shop and purchased this pair of bowling shoes. They are perfect in every way except that they are two sizes too big for me. When I wear them, I must walk slowly and carefully, paying attention to every step. In this way I am encouraged to be in the moment. But still, time is fleeting and fleeing. And still.

We drank tea on the terrace.
The fluttering awning had yellow and white stripes.

I sleep in a bed under a quilt given to me by
my aunt, who swims in the ocean every
day at dawn. The ocean envelops her.
The fish jump around. There is the sun
and sand and vigorous exercises with
her friends. And then she goes home
to make breakfast for her family.
Eggs. Salad. Her husband sits on a stool
at the kitchen table wearing an undershirt
embroidered by his mother (who is long gone
and who used to sit on her terrace knitting
striped socks), who may or may not have

nursed a baby bear in her tiny village in Belarus.

This is the same village where my mother almost drowned in the River Sluch. In that village there were dogs. And bread baked by the women. And shoes. And rooms that had to be swept. And the singing of songs. The lighting of candles. People lived. People died.

Everything is part of everything.

BOOK. FISH. SUIT. TIME.
MOTHER. FATHER. LIFE.

With Appreciation and Gratitude to
 First and Foremost
Elizabeth Sullivan · editor at Harper Collins
Lynne Yeamans · and designer
 and
 Caroline Baumann, Cara McCarty
 Gail Davidson, Jocelyn Groom, Pamela Horn
 And to Caitlin Condell and all at Cooper-Hewitt

 Harry Rubenstein Curator at the National Museum
 of American History at the
 Smithsonian in Washington, D.C.
 George Thomas Restorer of Abraham Lincoln's Watch
 (he made it Tick!)

And of course to Charlotte Sheedy, Julie Saul,
 Rick Meyerowitz, Michael Maharam, Paul Holdengraber,
 Kika Schoenfeld, Elizabeth Beautyman and
 Pesach Berman, Sara Berman, The little village of Lenin,
 the Blind geese herder, the city of Tel Aviv, the city
 of New York. Doors, beds, photos, books, trees, and Tibor

PHOTO CREDITS

INDEX OF IMAGES

PAGE 36: Square, Egypt, 5th–7th century. Wool slit tapestry. 15.3 × 14.6 cm (6 × 5³/₄ in.). Gift of John Pierpont Morgan, 1902-1-72. Photo by Andrew Garn © Smithsonian Institution.

PAGE 40: Cap, Egypt, late 13th or early 14th century. Quilted and embroidered silk with gilded parchment. H × diam.: 11.4 × 15.2 cm (4¹/₂ × 6 in.). Museum purchase through gift of Anonymous Donor, 1949-64-7. Photo by Matt Flynn © Smithsonian Institution.

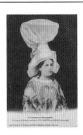

PAGE 42: Postcard, A Travers la Normandie: Coiffes et Costumes anciens, ca. 1909. Paul Bunel (French, 1882–1918). Printed card with hand coloring. 14 × 9.2 cm (5¹/₂ × 3⁵/₈ in.). Courtesy of the Smithsonian Institution Libraries, Washington, D.C. Photo by Demian Cacciolo © Smithsonian Institution.

PAGE 43: Postcard, La Basse-Normandie Pittoresque, Le Bonnet Rond, ca. 1910. Anet Veyssieres (French, active early 20th century) for Jean-Baptiste Le Goubey (French, 1879–1935). Printed card. 14 × 9.2 cm (5¹/₂ × 3⁵/₈ in.). Courtesy of the Smithsonian Institution Libraries, Washington, D.C. Photo by Demian Cacciolo © Smithsonian Institution.

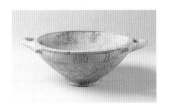

PAGE 44: Kylix, ca. 800 B.C. Greece. Painted earthenware. H × W × D: 7.3 × 22 × 18 cm (2⁷/₈ × 8¹¹/₁₆ × 7¹/₁₆ in.). Gift of Ruth Vollmer, 1971-48-12. Photo by Matt Flynn © Smithsonian Institution.

PAGE 45: Textile (detail), Campagna, designed 1942, introduced by Knoll 1947. Angelo Testa (American, 1921–1984). Produced by Knoll Associates, Inc. (New York). Screen printed linen. 136.5 × 65.7 cm (53³/₄ × 25⁷/₈ in.). Gift of Nicholas A. Pappas, FAIA, 2002-14-2. Photo by Andrew Garn © Smithsonian Institution.

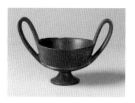

PAGE 46: Kantharos, late 7th–early 6th century B.C. Southern Eturia, Italy. Glossy black and dark gray biscuit control-fired earthenware. H × W × D: 11.5 × 17.2 × 11.4 cm (4¹/₂ × 6³/₄ × 4¹/₂ in.). Gift of Ruth Vollmer, 1971-48-13. Photo by Matt Flynn © Smithsonian Institution.

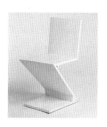

PAGE 47: Chair, Zig-Zag, ca. 1934. Netherlands. Gerrit Rietveld (Dutch, 1888–1964). Joined and painted elm. H × W × D: 73.8 × 36.8 × 42.5 cm (29¹/₁₆ × 14⁷/₁₆ × 16³/₄ in.). Museum purchase from Decorative Arts Association Acquisition Fund, 1994-60-1. Photo by Dave King © Smithsonian Institution.

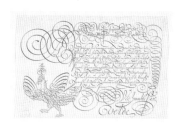

PAGES 48–49: Print, Writing Example from Literary Treasure, Spieghel der Schrijfkonste, tweede Deel (*The Mirror of Calligraphy*, Second Part), 1609. Jan van de Velde I (Dutch, 1569–1623). Engraved by Simon Weynouts Frisius (Flemish, ca. 1580–1628). Engraving on laid paper. 20.4 × 31.1 cm (8¹/₁₆ × 12¹/₄ in.). Gift of William J. Donald, 1954-18-30. Photo by Matt Flynn © Smithsonian Institution.

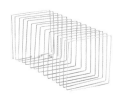

PAGE 50: Bracelet, ca. 1993. Netherlands. Marijke de Goey (Dutch, b. 1947). Bent steel wire. H × W × D: 6 × 6.6 × 3.5 cm (2³/₈ × 2⁵/₈ × 1³/₈ in.). Museum purchase from Decorative Arts Association Acquisition Fund, 1993-114-3. Photo by Matt Flynn © Smithsonian Institution.

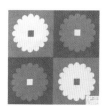

PAGE 52: Sample, Giant Mikado, 1954. Alexander Hayden Girard (American, 1907–1993). Manufactured by Herman Miller Textiles (Zeeland, MI). Screen printed cotton and wool. 59.1 × 59.1 cm (23¹/₄ × 23¹/₄ in.). Gift of Alexander H. Girard, 1969-165-26. Photo by Matt Flynn © Smithsonian Institution.

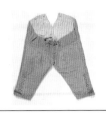

PAGE 54: Breeches, France, 1750–1770. Silk, linen lining. 69.9 × 50.2 cm (27½ × 19¾ in.). Gift of International Business Machines Corp., 1960-88-9-b. Photo by Matt Flynn © Smithsonian Institution.

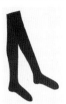

PAGE 55: Pair of stockings, France, 1850–1900. Knitted silk. 83.8 × 21 cm (33 × 8¼ in.) each. Gift of Mrs. William P. Treadwell, 1916-33-205-a,b. Photo by Matt Flynn © Smithsonian Institution.

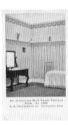

PAGE 55: Postcard, Trade card advertisement for S. A. Maxwell Wallpaper & Co., 1909. Offset lithograph on heavy paper. 14 × 9 cm (5½ × 3⁹⁄₁₆ in.). Gift of Anonymous Donor, 1992-68-1. Photo by Matt Flynn © Smithsonian Institution.

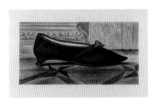

PAGE 56, TOP: Book, Ladies' old-fashioned shoes, Plate XI, 1885. By T. Watson Greig. Published by David Douglas (Edinburgh). Chromolithographic print, paper. 29 × 45 cm (11½ × 17¾ in.). GT2130 .G82la 1885. Courtesy of the Smithsonian Institution Libraries, Washington, D.C. © Smithsonian Institution.

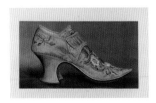

PAGE 56, BOTTOM: Book, Ladies' old-fashioned shoes, Plate X, 1885. By T. Watson Greig. Published by David Douglas (Edinburgh). Chromolithographic print, paper. 29 × 45 cm (11½ × 17¾ in.). GT2130 .G82la 1885. Courtesy of the Smithsonian Institution Libraries, Washington, D.C. © Smithsonian Institution.

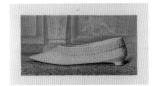

PAGE 57, TOP: Book, Ladies' old-fashioned shoes, Plate VII, 1885. By T. Watson Greig. Published by David Douglas (Edinburgh). Chromolithographic print, paper. 29 × 45 cm (11½ × 17¾ in.). GT2130 .G82la 1885. Courtesy of the Smithsonian Institution Libraries, Washington, D.C. © Smithsonian Institution.

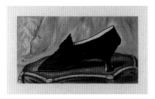

PAGE 57, BOTTOM: Book, Ladies' old-fashioned shoes, Plate I, 1885. By T. Watson Greig. Published by David Douglas (Edinburgh). Chromolithographic print, paper. 29 × 45 cm (11 1/2 × 17 3/4 in.). GT2130 .G82la 1885. Courtesy of the Smithsonian Institution Libraries, Washington, D.C. © Smithsonian Institution.

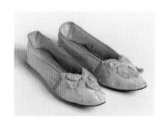

PAGES 58-59: Pair of slippers, United States, 1830s. Leather sole and upper, linen lining, silk bows. 5.7 × 6 × 22.9 cm (2 1/4 × 2 3/8 × 9 in.). Gift of Mrs. Robert P. Brown, 1960-81-18-a,b. Photo by Matt Flynn © Smithsonian Institution.

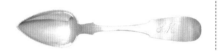

PAGES 60-61: Spoon, 1820–42. Hagerstown, Maryland. Frederick J. Posey (American, active 1820–40). Molded sheet silver. L × W × D: 15 × 3 × 1.6 cm (5 7/8 × 1 3/16 × 5/8 in.). Gift of Thomas S. Tibbs, 1959-181-1. Photo by Matt Flynn © Smithsonian Institution.

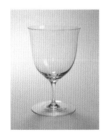

PAGE 62: Goblet, Patrician. Designed 1917, made ca. 1928. Vienna, Austria. Josef Hoffmann (Czech, 1870–1956; active Germany, Austria 1891–1955). Manufactured by J. and L. Lobmeyr (Austria). Mold-blown muslin glass. H × diam.: 13.8 × 8.9 cm (5 7/16 × 3 1/2 in.). Gift of Elisha Dyer, 1941-3-6. Photo by Ellen McDermott © Smithsonian Institution.

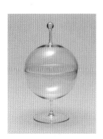

PAGE 63: Bonbonnière and cover, Ambassador, 1926. Vienna, Austria. Oswald Haerdtl (Austrian, 1899–1959). Manufactured by J. and L. Lobmeyr (Austria). Mold-Blown muslin glass. H × diam.: 22.6 × 12.5 cm (8 7/8 × 4 15/16 in.). Museum purchase through gift of Georgiana L. McClellan, 1958-98-21-a,b. Photo by Matt Flynn © Smithsonian Institution.

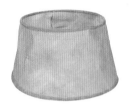

PAGE 66: Lamp, Bulb, 1966. Germany. Ingo Maurer (German, b. 1932). Glass, chrome-plated metal, incandescent bulb. H × diam.: 29.2 × 20.3 cm (11 1/2 × 8 in.). Gift of Ingo Maurer, 2008-16-1. Photo by Ellen McDermott © Smithsonian Institution. Object Copyright © Ingo Maurer.

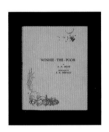

PAGE 67: Lamp shade, ca. 1935. France. Jean Michel Frank (French, 1895–1941). Parchment, velvet (edging). H × diam.: 15 × 22 cm (5 7/8 × 8 11/16 in.). Gift of Mr. and Mrs. Forsythe Sherfesee, 1968-144-21. Photo by Ellen McDermott © Smithsonian Institution.

PAGE 68: Book, *Winnie-the-Pooh*, 1926. By A. A. Milne (English, 1882–1956). Illustrated by Ernest H. Shepard (English, 1879–1976). Published by E. P. Dutton & Company, New York. Printed cover. 23 × 19 cm (9 1/16 × 7 1/2 in.) PR6025 .I65W5 1926. Courtesy of the Smithsonian Institution Libraries, Washington, D.C. © Smithsonian Institution.

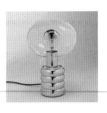

PAGE 69: Book, *Alice's Adventures in Wonderland and Alice Through the Looking Glass*, ca. 1899. By Lewis Carroll (English, 1832–1898). Illustrated by John Tenniel (English, 1820–1914). Published by Donohue, Henneberry (Chicago). Printed paper. 25 × 20 cm (9 13/16 × 7 7/8 in.). Gift of Kent C. Boese, PR4611 .A7 1899. Courtesy of the Smithsonian Institution Libraries, Washington, D.C. © Smithsonian Institution.

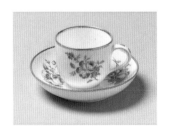

PAGE 70: Cup and saucer, ca. 1780. France. Manufactured by Sèvres Porcelain Manufactory (France, founded 1738). Soft-paste porcelain. H × diam.: 8 × 13.5 cm (1 3/8 × 5 7/8 in.). Gift of Mrs. Morris Hawkes, 1942-25-20-a,-c). Photo by Matt Flynn © Smithsonian Institution.

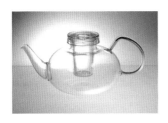

PAGE 71: Teapot, infuser and lid, ca. 1930–34. Germany. Wilhelm Wagenfeld (German, 1900–1990). Manufactured by Jenaer Glaswerke Schott und Genossen (Germany). Mold-blown glass. H × W × D: 11.5 × 26 × 14 cm (4½ × 10¼ × 5½ in.). Museum purchase from General Acquisition Endowment, 1987-8-1-a/c. Photo by Ellen McDermott © Smithsonian Institution.

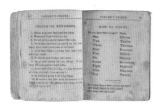

PAGE 74: Book, *Peter Parley's Primer*, 1835. By Samuel G. Goodrich (American, 1793–1860). Published by T. T. Ash (Philadelphia). Printed paper. Open: 14 × 24 cm (5½ × 9⁷/₁₆ in.). Gift of Mr. Lea S. Luquer, PE1119.A1 G66 1835. Courtesy of the Smithsonian Institution Libraries, Washington, D.C. © Smithsonian Institution.

PAGE 75: Book, *The First Lessons in Numbers*, 1868. By S. A. Felter. Published by Scribner, Armstrong, & Co. (New York). Front endpapers. Open: 16 × 20.5 cm (6⁵/₁₆ × 8¹/₁₆ in.) Gift of Mr. Erskine Hewitt. QA103 .F3254 1868X. Courtesy of the Smithsonian Institution Libraries, Washington, D.C. © Smithsonian Institution.

PAGES 76–77: Sampler, United States, ca. 1915. Embroidered by Miss Francesca Amari, student at Scuola d'Industrie Italiane (New York). Embroidered linen. 10.2 × 61 cm (4 × 24 in.). Gift of Mrs. Gino Speranza, 1942-47-7. Photo by Matt Flynn © Smithsonian Institution.

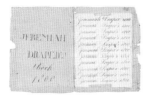

PAGES 80–81: Book, *Jeremiah Draper's Book*, 1800. Jeremiah Draper (American, active 1800s). Pen and black ink on laid paper. Open: 23.2 × 35.5 cm (9¹/₈ in. × 14 in.). Gift of Thomas Strahan Company, 1976-48-61-2. Photo by Matt Flynn © Smithsonian Institution.

PAGE 83: Album, *Autograph Album with Illustrations*, 18th century. Georg Phillip Rugendas (German, 1666–1742). Tooled, gilt leather binding; brush and gouache on laid paper. 9.7 × 15 × 4 cm (3¹³/₁₆ × 5⁷/₈ × 1⁹/₁₆ in.). Gift of Unknown Donor, 1980-32-1307. Photo by Matt Flynn © Smithsonian Institution.

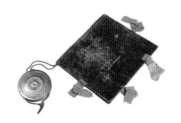

PAGE 85: Book, Certificate of authorization for the title of "Von" for Johann Ferdinand Richter, April 7, 1785. Franz Mayer (Austrian, active 1750s). Pen and ink, brush and watercolor over engraving on vellum, bound in velvet-covered boards with imperial seal in brass case. 37 × 33 cm (14⁹/₁₆ in. × 13 in.), (case diam.). 14.9 cm (5⁷/₈ in.). Museum purchase through gift of Erskine Hewitt, 1962-194-1. Photo by Matt Flynn © Smithsonian Institution.

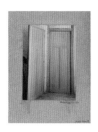

PAGE 86: Photograph, *Construction of a Mass-Operational House (No. 47)*, 1921. Hector Guimard (French, 1867–1942). Photographic print on sensitized paper mounted on gray paper. 33.4 × 28.5 cm (13¹/₈ × 11¹/₄ in.). Gift of Mme. Hector Guimard, 1951-160-2-47. Photo by Matt Flynn © Smithsonian Institution.

PAGE 90: Mount, ca. 1810. France or Italy. Gilt bronze. H × W × D: 11.5 × 7 × 0.7 cm (4½ × 2³/₄ × ¹/₄ in.). Gift of Mrs. George B. McClellan, 1907-3-13. Photo by Matt Flynn © Smithsonian Institution.

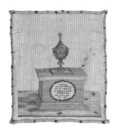

PAGE 92: Mourning sampler, England, ca. 1800. Silk, embroidered in silk. 26 × 22.9 cm (10¹/₄ × 9 in.). Gift of Anonymous Donor from the Fraser/Martin Collection, 1974-100-13. Photo by Matt Flynn © Smithsonian Institution.

PAGE 93: Mourning sampler, England, ca. 1810. Silk, embroidered with silk and painted. 41 × 39.5 cm (16⅛ × 15⁹⁄₁₆ in.). Gift of Anonymous Donor from the Fraser/Martin Collection, 1974-100-30. Photo by Matt Flynn © Smithsonian Institution.

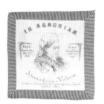

PAGE 94: Handkerchief, In Memoriam, 1901. Roller printed cotton. 37.8 × 37.8 cm (14⅞ × 14⅞ in.). Gift of Paul F. Walter, 2008-21-1. Photo by Matt Flynn © Smithsonian Institution.

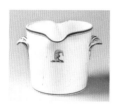

PAGE 95: Wineglass rinser, late-18th century. Etruria, England. Glazed earthenware. 10.9 × 16 cm (4⁵⁄₁₆ × 6⁵⁄₁₆ in.). Bequest of Erskine Hewitt, 1938-57-425. Photo by Matt Flynn © Smithsonian Institution.

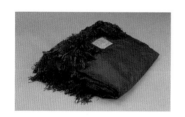

PAGE 98: Coffin cover, Abraham Lincoln's Funeral Pall, April 28, 1865. United States. Black silk. 360.68 × 157.48 cm (142 × 62 in.). Gift of the Lake County Historical Society, 1962. 242158. Division of Political History, National Museum of American History, Smithsonian Institution. © Smithsonian Institution.

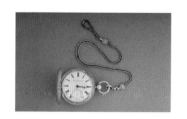

PAGE 99: Watch, Abraham Lincoln's Watch, ca. 1858. England (works), United States (case). Gold, glass, and metal. Watch: 5.08 × 7.62 × 1.27 cm (2 x 3 × ½ in.); watch chain: 33.02 cm (13 in.). Gift of Lincoln Isham, great-grandson of Abraham Lincoln, 1958. 219098.1. Division of Political History, National Museum of American History, Smithsonian Institution. © Smithsonian Institution.

PAGE 100: Sampler, Mexico, 19th century. Made for Matilde Thompson. Linen, embroidered in linen and silk. 27 × 32.1 cm (10⅝ × 12⅝ in.). Bequest of Mrs. Henry E. Coe, 1941-69-132. Photo by Matt Flynn © Smithsonian Institution.

BIBLIOGRAPHY

Benjamin, Walter. *Illuminations: Essays and Reflections.* New York: Schocken Books, 1968.

Carroll, Lewis. *Alice's Adventures in Wonderland.* London: Macmillan, 1865.

Darwin, Charles. *The Correspondence of Charles Darwin.* Vol. 9, 1861, excerpt from the 1994 edition. New York: Cambridge University Press, 1994.

Neruda, Pablo. "An Ode to Things" (1959). From *All the Odes,* edited by Ilan Stavans. New York: Farrar, Straus & Giroux, 2013.

Shapiro, Fred R., ed. *The Yale Book of Quotations.* New Haven: Yale University Press, 2006.

Wittgenstein, Ludwig. *On Certainty,* edited by G. E. M. Anscombe and G. H. von Wright. Translated by Paul Denis and G. E. M. Anscombe. New York: Harper & Row, 1969.

First published in 2014 by
Harper Design
An Imprint of HarperCollins *Publishers*
195 Broadway
New York, NY 10007
Tel: (212) 207-7000
Fax: (212) 207-7654

www.harpercollinspublishers.com
harperdesign@harpercollins.com

Distributed throughout the world by
HarperCollins *Publishers*
195 Broadway
New York, NY 10007

ISBN 978-0-06-212297-1

Library of Congress Control Number: 2011941337

Printed in China

First Printing, 2014

MAIRA KALMAN is an author and illustrator of numerous books for adults and children. She is a contributor to *The New Yorker* and the *New York Times*. Born in Tel Aviv, she lives in New York City. www. mairakalman.com.